THE FUNDAMENTALS OF
DRAWING
NUDES

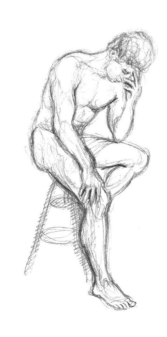

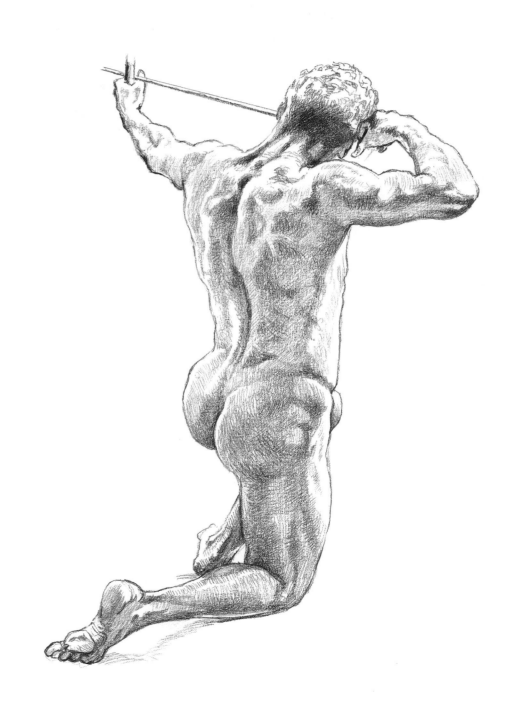

THE FUNDAMENTALS OF
DRAWING
NUDES

Barrington Barber

ARCTURUS

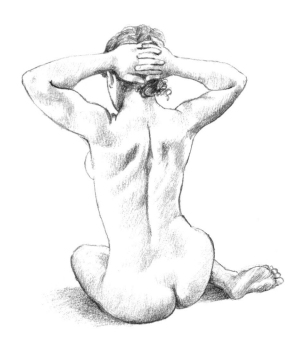

Arcturus

This edition published in 2021 by Arcturus Publishing Limited
26/27 Bickels Yard, 151–153 Bermondsey Street,
London SE1 3HA

ISBN: 978-1-3988-0413-5
AD008161UK

Printed in China

Contents

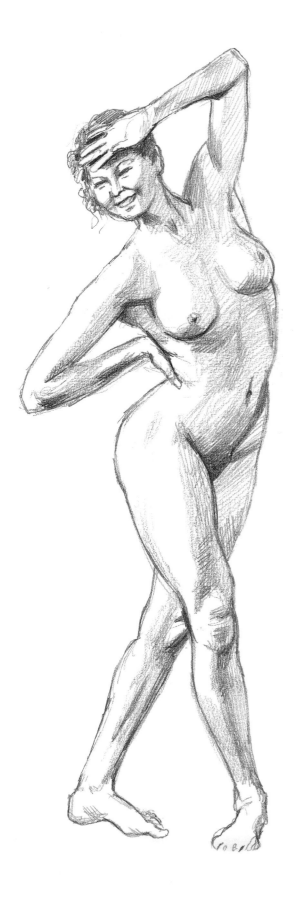

Introduction

The nude human figure is both the hardest and the most satisfying subject for any artist. It is technically challenging, as viewers of your work will know the proportions and movements of the human body and may spot any mistakes. But for you as an artist there is great interest in attempting that most subtle and mobile of subjects – the living human body.

The aim of this book is to explore the practices necessary to achieve a good level of drawing the nude human figure. We shall look first at how the body is formed, from its skeleton – the structure that all figures are based on – down to the details of the torso, limbs, the hands and feet and the head. A certain degree of scientific information is most helpful for understanding how the shape of the body alters with – for example – the movement of the limbs and torso. Without at least a little knowledge of anatomy, it is difficult to impart a sense of flow and movement to your figure drawing.

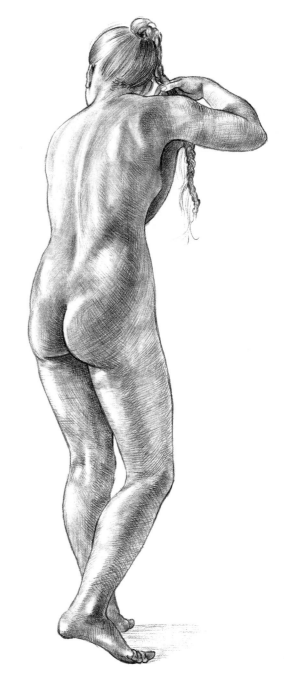

Once you have some knowledge of how the average figure is constructed you can consider how to go about drawing it. To draw the nude form effectively, you really need to study a figure from life, either at a life class or at home if you are fortunate enough to have a model available. When working with a model, you should consider not just their individual appearance but also the lighting, the pose you want to draw and how long you want them to hold the pose. I will suggest how you might go about making your first drawings of the figure before developing your skills to render it as a convincingly three-dimensional form. Dynamic poses bring new challenges as you identify the more unusual forms the body can take, while capturing a figure in movement will require an experimental approach.

The techniques of drawing will also be examined, and the ways in which different artists have portrayed the human figure, from the most detailed renditions to the most expressive. Of course, this book does not pretend to be exhaustive, as life drawing has been developed and explored over centuries as artists have sought new ways of portraying the human form. With the infinite variety of individual bodies and the range of movement and poses they can adopt, an artist focused on life drawing never runs out of opportunities.

Drawing Materials

You don't need to buy all the items listed below, and it is probably wise to experiment: start with the range of pencils suggested, and when you feel you would like to try something different, then do so. A good-quality eraser (preferably a kneadable putty eraser) is essential, along with a craft knife or sharpener. A paper stump is also useful for smoothing over your shaded areas.

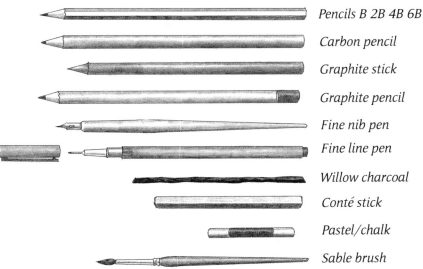

Pencils B 2B 4B 6B

Carbon pencil

Graphite stick

Graphite pencil

Fine nib pen

Fine line pen

Willow charcoal

Conté stick

Pastel/chalk

Sable brush

Pencil

The normal type of wooden-cased drawing pencil is, of course, the most versatile instrument at your disposal. You will find the soft black pencils are best. Mostly I use B, 2B, 4B and 6B. Very soft pencils (7B–9B) can be useful sometimes and harder ones (H) very occasionally. Propelling or clutch pencils are very popular, although if you choose this type you will need to buy a selection of soft, black leads with which to replenish them.

Carbon pencil

This can give a very attractive, slightly unusual result, especially the dark brown or sepia, and the terracotta or sanguine versions. The black version is almost the same in appearance as charcoal, but you can't rub it out so easily if you make a mistake.

Graphite

Graphite pencils are thicker than ordinary pencils and come in an ordinary wooden casing or as solid graphite sticks with a thin plastic covering. The solid stick is very versatile because of the breadth of the drawing edge, enabling you to draw a line 6 mm (¼ in) thick, or even thicker, and also very fine lines. Graphite also comes in various grades, from hard to very soft and black.

Pens

Push-pens or dip-pens come with a fine-pointed nib, either stiff or flexible, depending on what you wish to achieve. Modern fine-pointed graphic pens are easier to use and less messy but not as versatile, producing a line of unvarying thickness. Try both types.

　　The ink for dip-pens is black Indian ink or drawing ink; this can be permanent or water-soluble. The latter allows greater subtlety of tone.

Charcoal

In stick form this medium is very useful for large drawings, because the long edge can be used as well as the point. Charcoal pencils (available in black, grey and white) are not as messy to use as the willow sticks but are less versatile. To keep charcoal drawings in good condition they must be fixed with a spray-on fixative to prevent smudging.

Conté

Conté crayon comes in different colours, different forms (stick or encased in wood like a pencil) and in grades from soft to hard. Like charcoal, it smudges easily but is much stronger in its effect and more difficult to remove.

Pastel/chalk

If you want to introduce colour into your figure drawing, either of these can be used. Dark colours give better tonal variation. Your choice of paper is essential to a good outcome with these materials. Don't use a paper that is too smooth, otherwise the deposit of pastel or chalk will not adhere to the paper properly. A tinted paper can be ideal, because it enables you to use light and dark tones to bring an extra dimension to your drawing.

Brush

Drawing with a brush will give a greater variety of tonal possibilities to your drawing. A fine tip is not easy to use initially, and you will need to practise if you are to get a good result with it. Use a soluble ink, which will give you a range of attractive tones.

　　A number 0 or number 2 nylon brush is satisfactory for drawing. For applying washes of tone, a number 6 or number 10 brush in sablette, sable or any other material capable of producing a good point is recommended.

CHAPTER 1: PROPORTIONS AND ANATOMY

The first chapter in this book explores the basic physiology of the human body, looking at the proportions and the underlying bone and muscle structure and then focusing in detail on the various body parts.

To draw the human figure successfully it is essential to have some idea of what lies beneath the skin. The bone structure is the basic scaffolding of the body, more visible in some places than others but everywhere dictating size and proportions. To a greater or lesser extent, the skeleton is enveloped in muscles, again with varying visibility. Consider the way the wrist bone is so obvious to the eye, while the thigh bone is hidden by muscle that, in someone athletic, forms distinct bulges that disrupt the smooth line of the thigh; such observations should become second nature to you with regular practice of drawing a live model.

In the second part of the chapter, I examine each part of the body in more detail, looking at the head, torso, arms, legs and extremities. Studying these features in isolation is never time wasted, as putting in the groundwork at this stage will help you when you come to draw complete figures from life.

Proportions of the Human Figure

Here I have a front view and a back view of the male and female body. The two sexes are drawn to the same scale because I wanted to show how their proportions are very similar in relation to the head measurement. Generally, the female body is slightly smaller and finer in structure than that of a male, but of course sizes differ so much that you will have to use your powers of observation when drawing any individual.

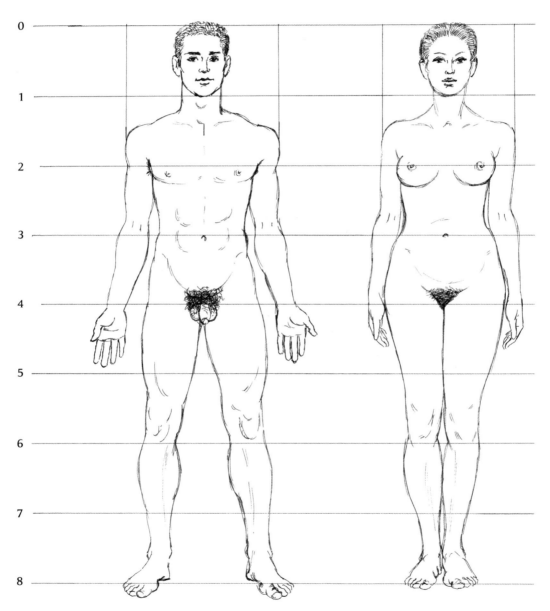

These drawings assume the male and female are both exactly the same height, with both sexes having a height of eight times the length of their head. As you can see, this means that the centre of the total height comes at the base of the pubis, so that the torso and head are the upper half of this measure, and the legs alone account for the lower half. Note where the other units of head length are placed: the second unit is just below the armpits, the third is at the navel, the fifth just below the middle of the thigh, the sixth below the knee joint and the seventh just below the calf. This is a very useful scale to help you get started.

These two examples are of the back view of the two people opposite, with healthy, athletic builds. The man's shoulders are wider than the woman's and the woman's hips are wider than the man's. This is, however, a classic proportion, and in real life people are often less perfectly formed. None the less, this is a good basic guide to the shape and proportion of the human body.

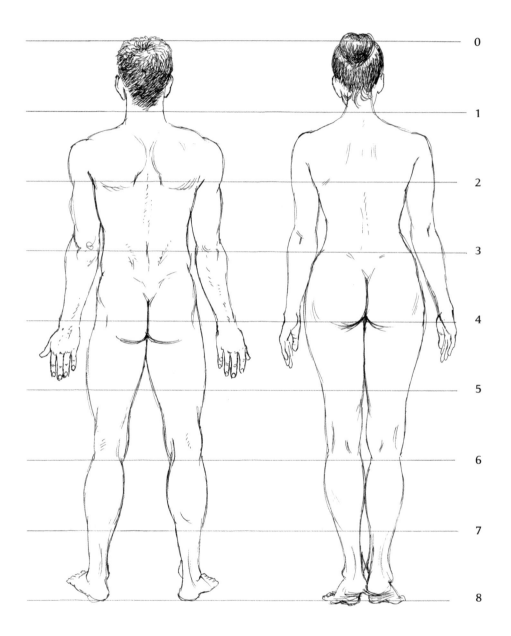

The man's neck is thicker in relation to his head while the female neck is more slender. Notice also that the female waist is narrower than the man's and the general effect of the female figure is smoother and softer than the man's more hard-looking frame.

This is partly due to the extra layer of subcutaneous fat that exists in the female body. Mostly the differences are connected with childbirth and breastfeeding; women's hips are broader than men's for the former reason too.

Individual Proportions

The greatest difference between adult bodies tends to be in the amount of flesh spread over the skeletal frame. While the proportion of head to height may be the same, the relative width of the body can be vastly different. This may be a result of lifestyle choices such as diet and exercise or of the individual's metabolism. A broad appearance may be caused by muscle rather than fat, but the distribution and appearance of the bulk will be very different.

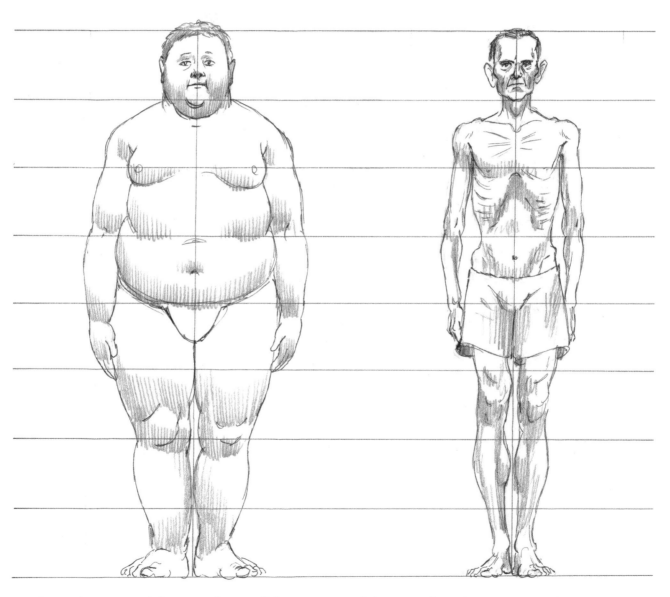

Most extra fat gathers around the central area of the body, and the first area to increase in width is usually the waist. The upper parts of the legs and arms are often thicker and there tends to be extra bulk around the neck and chest. At the other extreme, when someone is below normal weight, the human frame is reduced to a very meagre stringy-looking shape. The width of the torso and limbs is dictated only by the bone structure.

A man who spends time working out at the gym may have thick legs and arms and wide shoulders and chest, but will not have the large waist of a couch potato. Be aware that sportsmen may have muscular development particular to their chosen field, such as the exaggerated shoulder muscles of a boxer. Although an individual's form may be extreme in one way or another, this book mainly deals with average shapes.

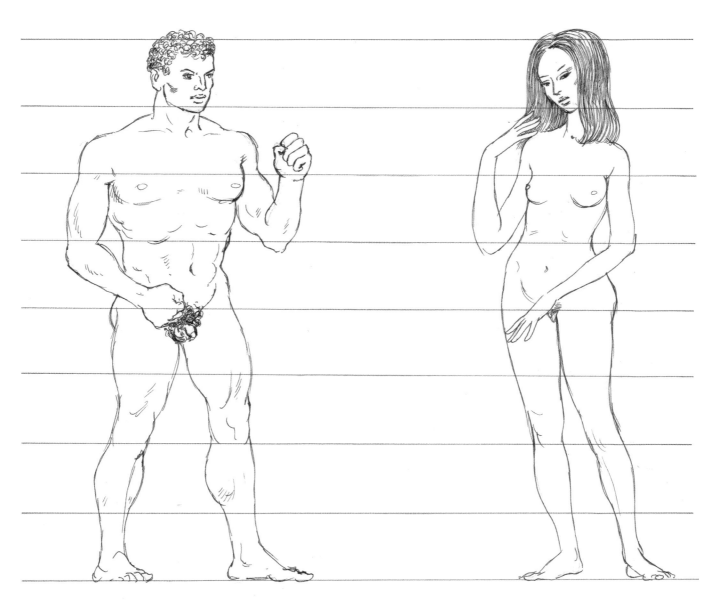

This athletic man has very well developed muscles that enable him to be strong and powerful for his sport. Notice the large chest in relation to the narrow waist and the muscular upper arms and legs.

This female figure looks more like a gymnast or dancer, having a slender willowy look that is slim, lightweight and suggests extreme suppleness with strength.

The Skeleton

The bony skeleton is rather like interior scaffolding, around which the softer parts of the body are built. It is important for the artist to know where the bone structure is visible because, when drawing, it helps to relate the fixed points of the figure to the appearance of the more fleshy parts.

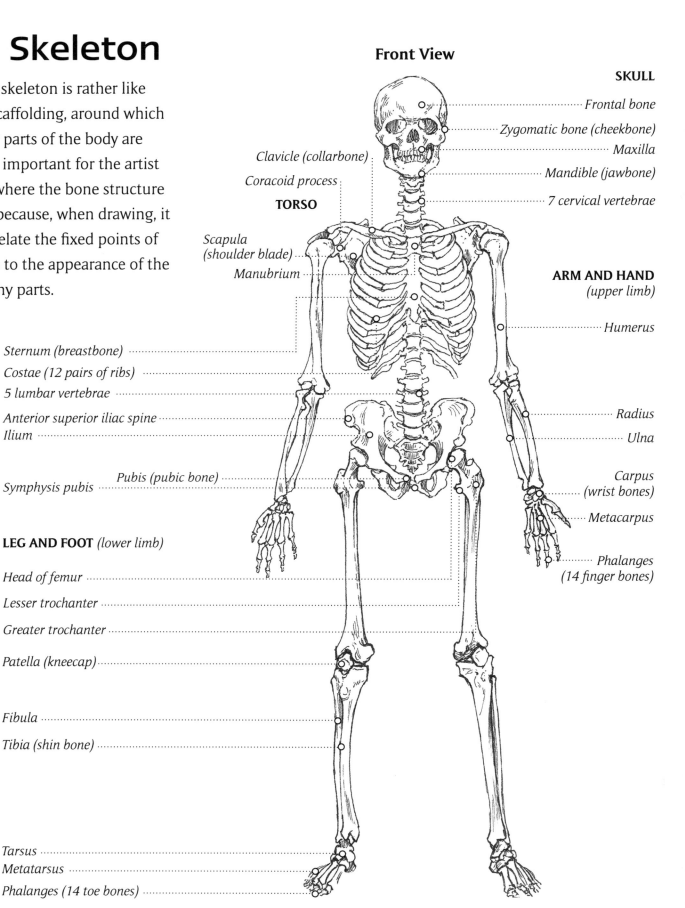

Front View

SKULL

Frontal bone

Zygomatic bone (cheekbone)

Maxilla

Mandible (jawbone)

7 cervical vertebrae

Clavicle (collarbone)

Coracoid process

TORSO

Scapula (shoulder blade)

Manubrium

ARM AND HAND *(upper limb)*

Humerus

Sternum (breastbone)

Costae (12 pairs of ribs)

5 lumbar vertebrae

Anterior superior iliac spine

Ilium

Radius

Ulna

Pubis (pubic bone)

Symphysis pubis

Carpus (wrist bones)

Metacarpus

LEG AND FOOT *(lower limb)*

Phalanges (14 finger bones)

Head of femur

Lesser trochanter

Greater trochanter

Patella (kneecap)

Fibula

Tibia (shin bone)

Tarsus

Metatarsus

Phalanges (14 toe bones)

Back View

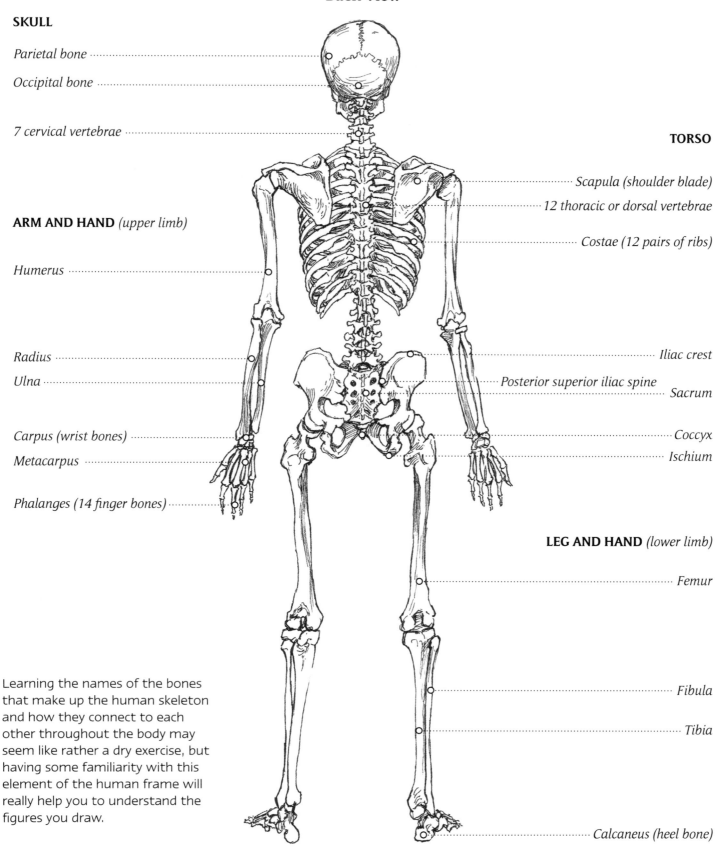

SKULL

Parietal bone

Occipital bone

7 cervical vertebrae

ARM AND HAND *(upper limb)*

Humerus

Radius

Ulna

Carpus (wrist bones)

Metacarpus

Phalanges (14 finger bones)

TORSO

Scapula (shoulder blade)

12 thoracic or dorsal vertebrae

Costae (12 pairs of ribs)

Iliac crest

Posterior superior iliac spine

Sacrum

Coccyx

Ischium

LEG AND HAND *(lower limb)*

Femur

Fibula

Tibia

Learning the names of the bones that make up the human skeleton and how they connect to each other throughout the body may seem like rather a dry exercise, but having some familiarity with this element of the human frame will really help you to understand the figures you draw.

Calcaneus (heel bone)

Musculature

We show here the musculature of the whole body, so as to give some idea of the complexity of the sheaths of muscles over the bone structure. These drawings are based on a male body. Of course there are slight differences between the male and female musculature, but not much in the underlying structure.

Front View

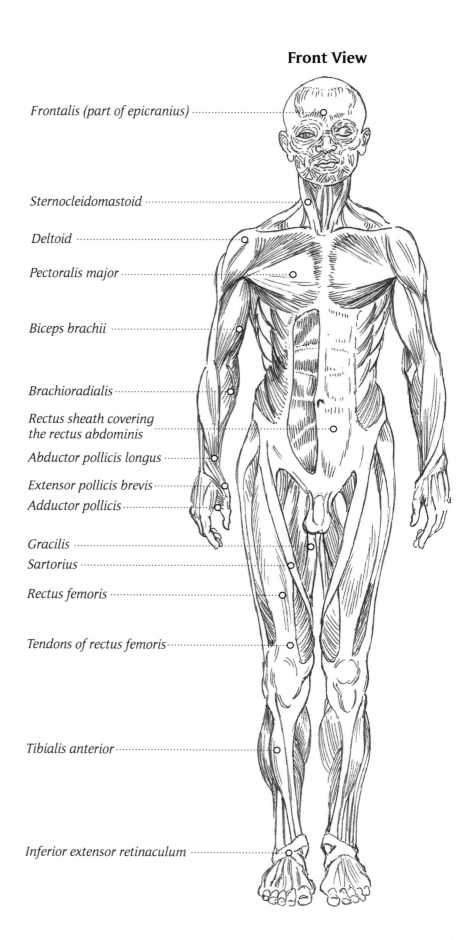

Frontalis (part of epicranius)

Sternocleidomastoid

Deltoid

Pectoralis major

Biceps brachii

Brachioradialis

Rectus sheath covering the rectus abdominis

Abductor pollicis longus

Extensor pollicis brevis

Adductor pollicis

Gracilis

Sartorius

Rectus femoris

Tendons of rectus femoris

Tibialis anterior

Inferior extensor retinaculum

Back View

As artists, our primary interest is in the structure of the muscles on the surface. There are two types of muscles that establish the main shape of the body and they are either striated, or more like smooth cladding. The large muscles are the most necessary ones for you to know and once you have familiarized yourself with these it is only really necessary to investigate the deeper muscles for your own interest. If you can remember the most obvious muscles, that is good enough for the purposes of drawing figures.

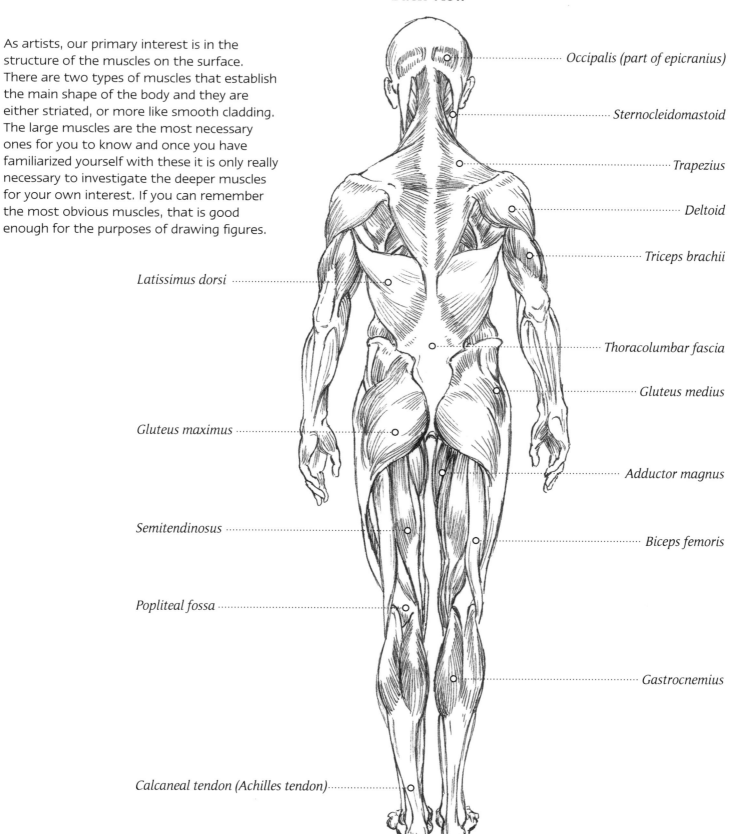

Occipalis (part of epicranius)

Sternocleidomastoid

Trapezius

Deltoid

Triceps brachii

Latissimus dorsi

Thoracolumbar fascia

Gluteus medius

Gluteus maximus

Adductor magnus

Semitendinosus

Biceps femoris

Popliteal fossa

Gastrocnemius

Calcaneal tendon (Achilles tendon)

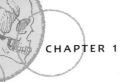

Identifying Bones and Muscles

When you come to examine the surface of the human body, all the bones and muscles we have looked at are rather disguised by the layers of fat and skin that cover them. For the artist this becomes a sort of detective story, through the process of working out which bulges and hollows represent which features underneath the skin.

To make this easier, I have shown drawings of the body from the front, back and side, highlighting the most prominent muscles and parts of the bone structure visible beneath the surface of the skin. Because, on the surface, the male and female shapes become more differentiated, I have drawn both sexes. The difference between the male and female shapes is clear, in that the male shoulders are wider than any other part of the body, while the female hips and shoulders are of a similar width. All these body types are based on an athletic form, because this shows more clearly the main features of muscle and bone.

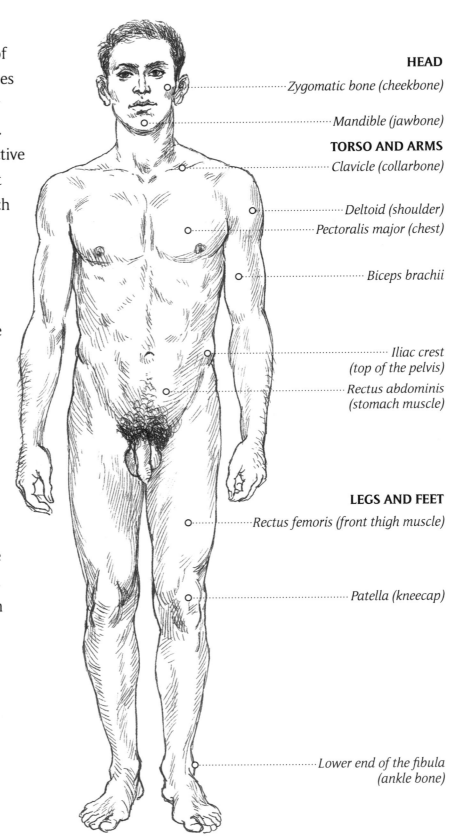

HEAD
Zygomatic bone (cheekbone)

Mandible (jawbone)
TORSO AND ARMS
Clavicle (collarbone)

Deltoid (shoulder)
Pectoralis major (chest)

Biceps brachii

*Iliac crest
(top of the pelvis)*
*Rectus abdominis
(stomach muscle)*

LEGS AND FEET
Rectus femoris (front thigh muscle)

Patella (kneecap)

*Lower end of the fibula
(ankle bone)*

HEAD

Frontalis (forehead)

TORSO AND ARMS

Clavicle (collarbone)

Deltoid (shoulder)

Navel

Lower end of radius
(wrist bone)

Patella (kneecap)

Lower end of tibia
(ankle bone)

Buccinator
(cheek muscle)

Sternocleidomastoid
(neck muscle)

Pectoralis major with
mammary gland (breast)

External oblique

Rectus abdominis
(stomach muscle)

LEGS AND FEET
Greater trochanter

Rectus femoris
(front thigh muscle)

Tibia (shin bone)

Lower end of fibula
(ankle bone)

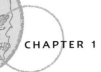

In these back and side views, I have again highlighted the most prominent muscles and parts of the bone structure visible on the surface of the body.

Sternocleidomastoid (neck muscle)

Trapezius (top of shoulder)

Acromion

Deltoid (shoulder)

Scapula (shoulder blade)

Teres major

Triceps brachii

Spinal groove

Latissimus dorsi (lower back)

Iliac crest (top edge of pelvis)

Styloid process of radius

Gluteus maximus (buttock)

Biceps femoris (back of thigh)

Iliotibial band

Popliteal fossa (ham)

Gastrocnemius (calf muscle)

Soleus (outer calf)

Calcaneal tendon (Achilles tendon)

Medial malleolus of tibia

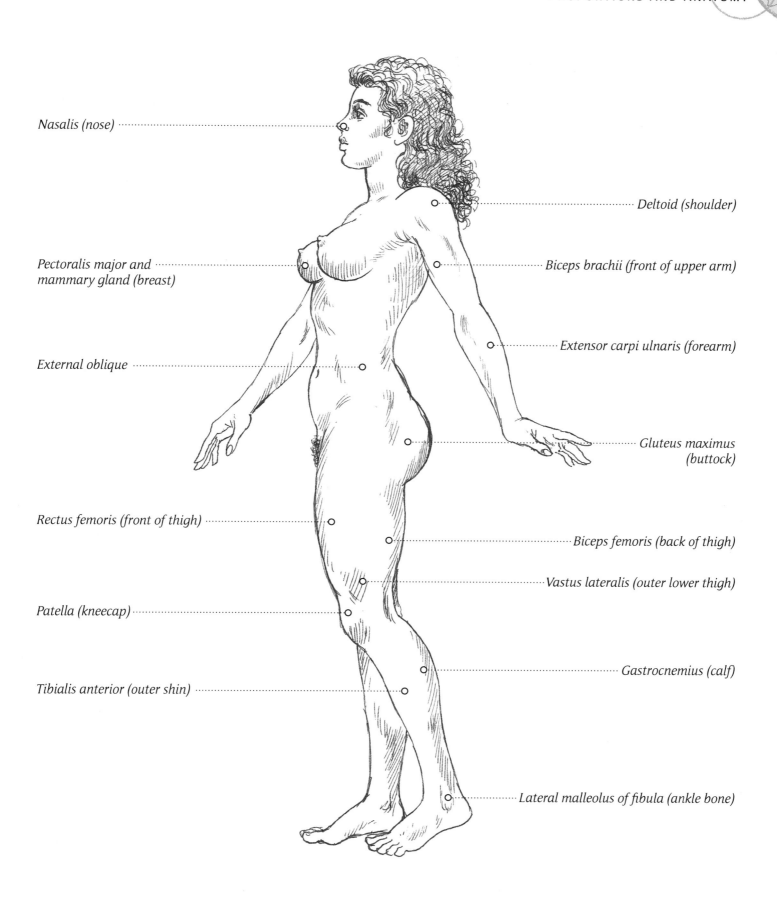

Nasalis (nose)

Pectoralis major and
mammary gland (breast)

External oblique

Rectus femoris (front of thigh)

Patella (kneecap)

Tibialis anterior (outer shin)

Deltoid (shoulder)

Biceps brachii (front of upper arm)

Extensor carpi ulnaris (forearm)

Gluteus maximus
(buttock)

Biceps femoris (back of thigh)

Vastus lateralis (outer lower thigh)

Gastrocnemius (calf)

Lateral malleolus of fibula (ankle bone)

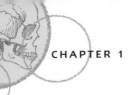

Proportions of the Head

The head proportions shown here are broadly true of adult humans of any race or culture. If this is the first time you have studied these measurements you may find some of them a little surprising; for example the eyes are not situated in the top half of the head, but exactly halfway down.

Profile View

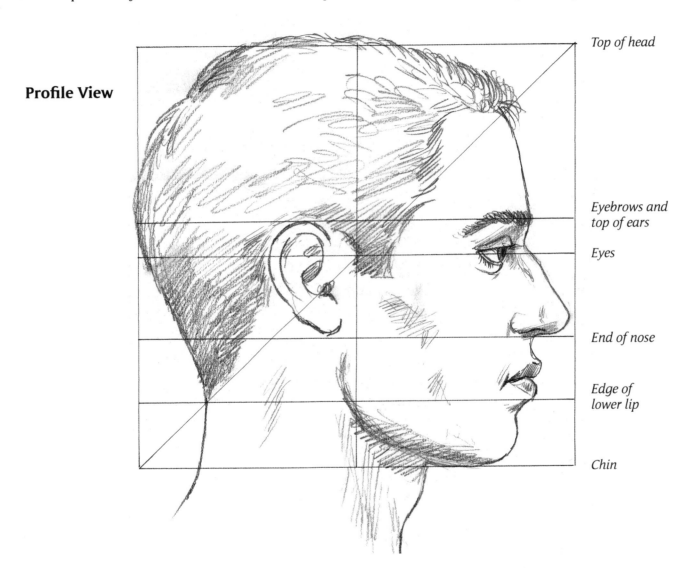

Top of head

Eyebrows and top of ears

Eyes

End of nose

Edge of lower lip

Chin

This view of the head can be seen proportionately as a square which encompasses the whole head. When this square is divided across the diagonal, it is immediately obvious that the mass of the hair area is in the top part of the diagonal and takes up almost all the space, except for the ears.

When the square is divided in half horizontally it's also clear that the eyes are halfway down the length of the head. Where the horizontal halfway line meets the diagonal halfway line is the centre of the square. The ears

appear to be at this centre point, but just behind the vertical centre line.

A line level with the eyebrow also marks the top edge of the ear. The bottom edge of the ear is level with the end of the nose, which is halfway between the eyebrow and the chin. The bottom edge of the lower lip is about halfway between the end of the nose and the chin.

While these measurements aren't exact, they are fairly accurate and will hold good for most people's heads.

From the front, as long as the head isn't tilted, it is about one and a half times as long as it is wide. The widest part is just above the ears.

Front View

As in the side view, the eyes are halfway down the length of the head and the end of the nose is halfway between the eyebrows and the chin; the bottom edge of the lip is about halfway between the end of the nose and the chin.

The space between the eyes is the same as the length of the eye. The width of the mouth is such that the corners appear to be the same distance apart as the pupils of the eyes, when looking straight ahead.

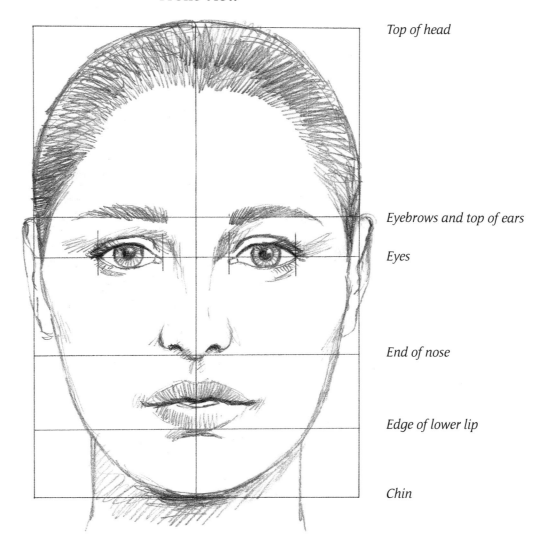

Top of head

Eyebrows and top of ears

Eyes

End of nose

Edge of lower lip

Chin

These are very simple measurements and might not be quite accurate on some heads, but as a rule you can rely on them – artists have been doing so for many centuries.

The Head from Different Angles

When it comes to drawing from life, it is unlikely that you will find your subject's head in exactly the full-face or profile view. Here I have drawn the head from a variety of different angles, emphasizing its three-dimensional quality and getting across the idea of the whole shape, not just the face. In the main there are no particular details of the face – just the basic structure of the head when seen from above, below and the side.

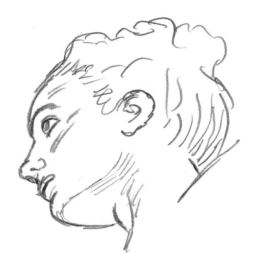
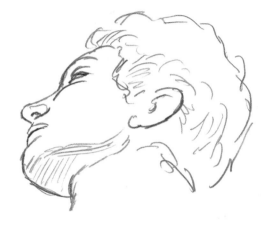
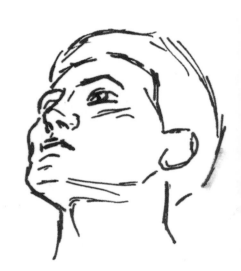

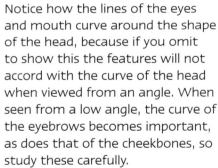

Notice how the lines of the eyes and mouth curve around the shape of the head, because if you omit to show this the features will not accord with the curve of the head when viewed from an angle. When seen from a low angle, the curve of the eyebrows becomes important, as does that of the cheekbones, so study these carefully.

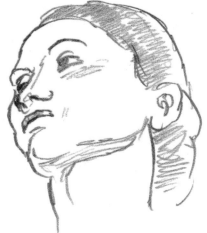

Sometimes the nose appears to be just a small point sticking out from the shape of the head, especially when seen from below. The underside of the chin also has a very characteristic shape, which is worth noting if you want your drawing to be convincing. Conversely, when seen from above, the chin and mouth almost disappear but the nose becomes very dominant. From above, the hair becomes very much the main part of the head, whereas when seen from below the hair may be visible only at the sides.

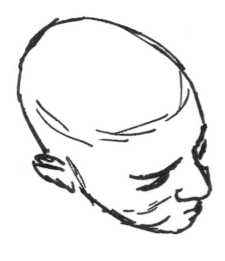

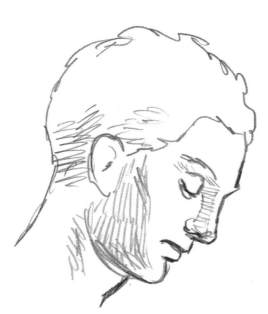

The Torso

Male and female torsos present very different surfaces for the artist to draw. Because most men are more muscular than women, light will fall differently upon the angles and planes of the body and there will be more shadowed areas where the skin curves away from the light. The viewer will immediately understand these darker areas as showing muscular structure. In the case of the female torso, the shadowed areas are longer and smoother, as the planes of the body are not disrupted by such obvious muscle beneath the skin. Of course, many people you draw from life will not be so well toned as these models.

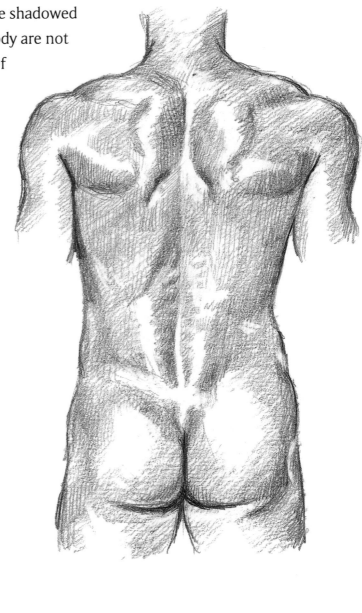

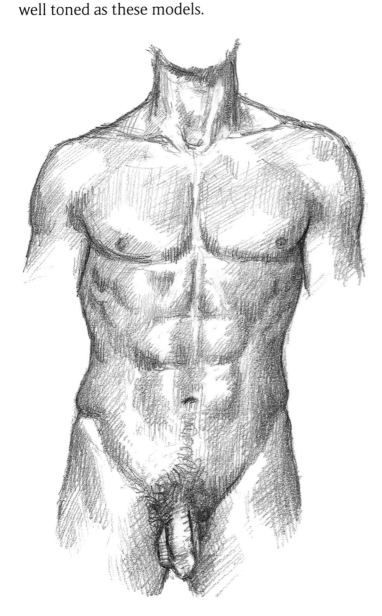

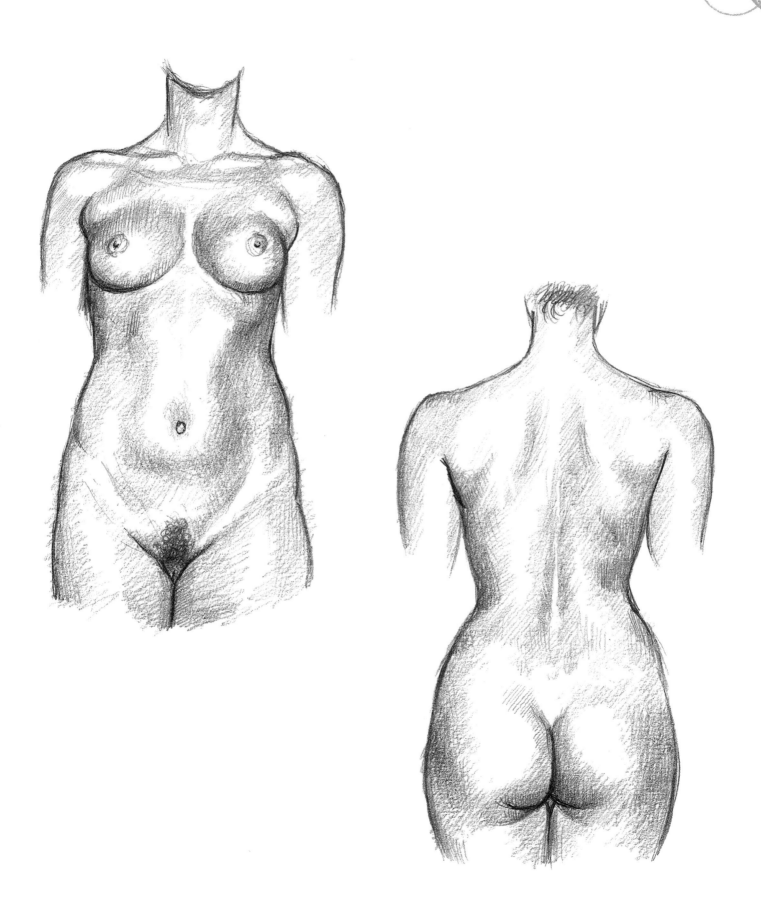

The torso: bending and stretching

The significant thing about the torso from an artist's point of view is that although it looks like a pretty solid piece of work, it is actually highly mobile. It can bend forwards, backwards and sideways, and stretch out and contract to some extent. It can also twist around, enabling the shoulders to face sideways from the hips.

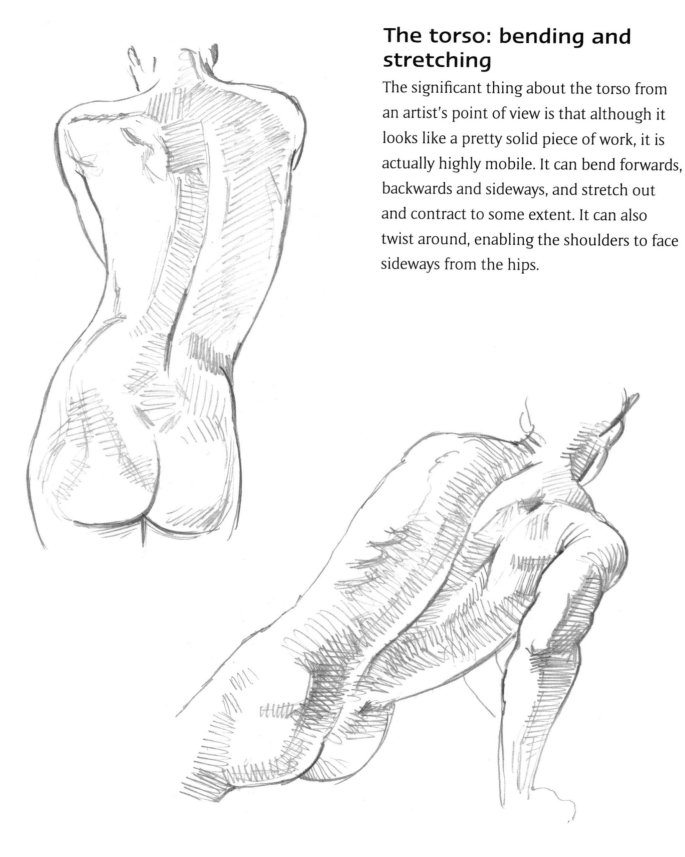

In these drawings you can see how the spinal cord is such a good indication of what is happening to the body when it bends and stretches. The curves of the spine help to define the pose very clearly and it is best to start drawing a figure by taking a note of them. All the other parts of the body's structure can then be built around that. Even if you can't see the spine, some idea of its curves will always help to keep your drawing convincing.

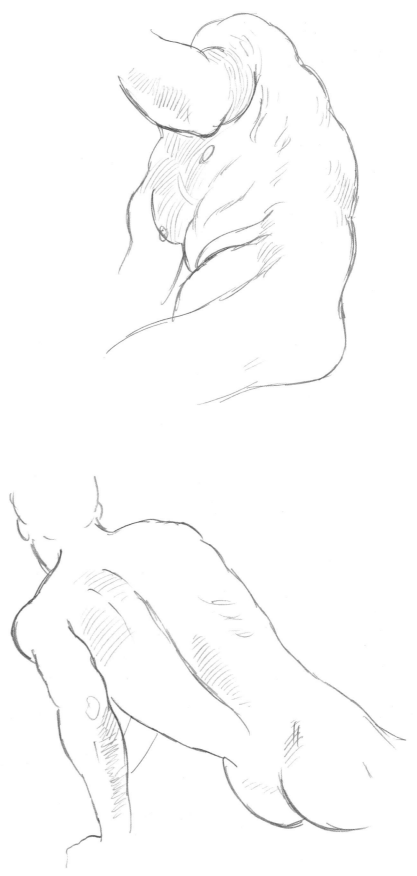

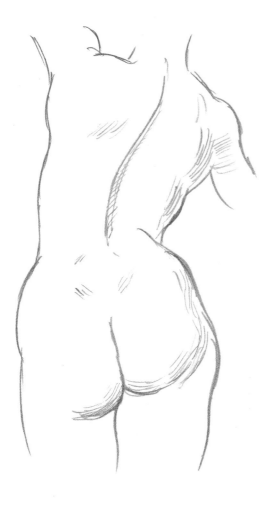

Arms and Hands

The narrowness of the limb makes the musculature show much more easily than in the torso, and at the shoulder, elbow and wrist it is even possible to see the end of the skeletal structure. This tendency of bone and muscle structure to diminish in size as it moves away from the centre of the body is something that should inform your drawings. Fingers and thumbs are narrower than wrists; wrists are narrower than elbows; elbows narrower than shoulders: a surprisingly large number of students draw them the opposite way round. As always, it is a matter of observing carefully and drawing what you actually see before you.

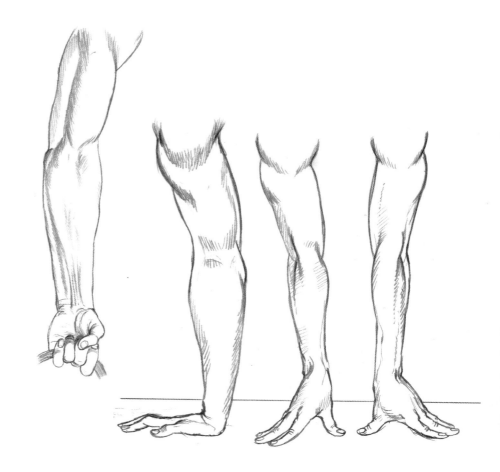

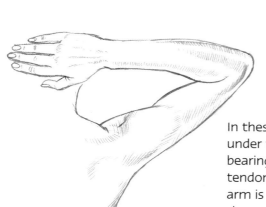

In these examples, notice how when the arm is under tension in the act of grasping an object or bearing weight, the muscles stand out and their tendons show clearly at the inner wrist. When the arm is bent, the larger muscles in the upper arm show themselves more clearly and the shoulder muscles and shoulder blades are also more defined.

Hands

Many people find hands difficult to draw. You will never lack a model here as you can simply draw your own free hand, so keep practising and study it from as many different angles as possible. The arrangement of the fingers and thumb into a fist or a hand with the fingers relaxed and open create very different shapes and it is useful to draw these constantly to get the feel of how they look. There is inevitably a lot of foreshortening in the palm and fingers when the hand is angled towards you or away from your sight.

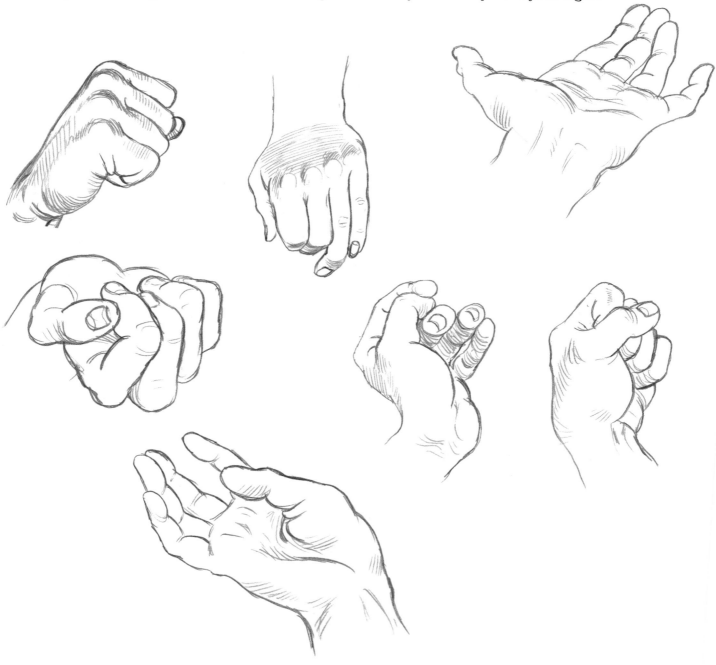

Legs and Feet

Our lower limbs are probably the most powerful parts of the body, having the largest bones and the strongest muscles. This is no surprise, since the legs not only support the total body weight but also have to propel it along in the world.

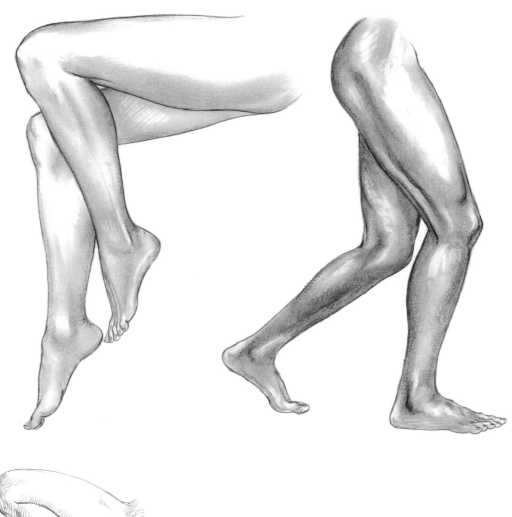

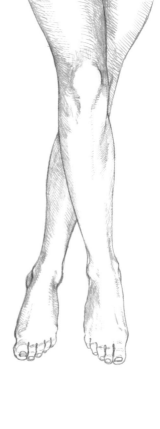

From the side, you will see that the muscles in the thigh and the calf of the leg show up most clearly, the thigh mostly towards the front of the leg and the calf towards the back. The large tendons show mostly at the back of the knees and around the ankle. Notice the way the patella changes shape as the knee is bent or straightened. As with the arms, the bones and muscles in the leg are bigger towards the body and smaller towards the extremities.

The back view of the legs shows the interesting reverse of the knee joint and looks very round and smooth, especially in the female form.

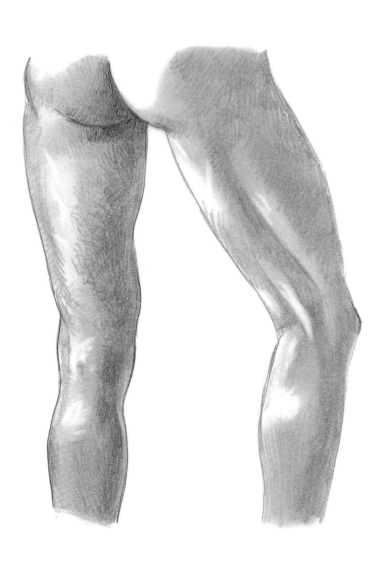

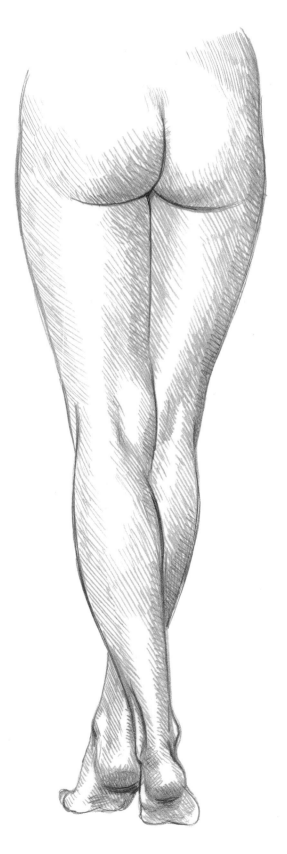

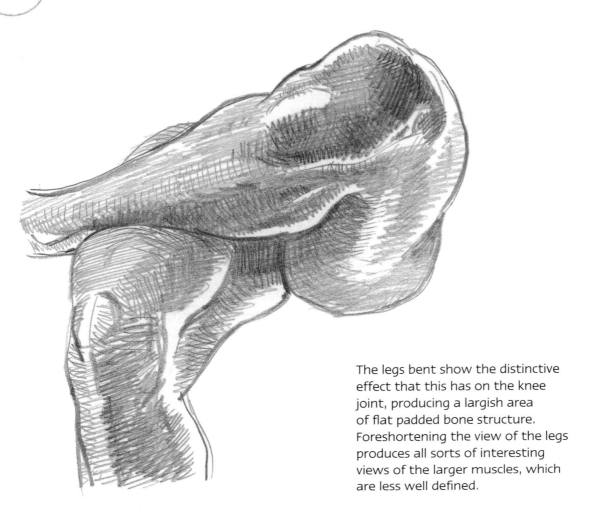

The legs bent show the distinctive effect that this has on the knee joint, producing a largish area of flat padded bone structure. Foreshortening the view of the legs produces all sorts of interesting views of the larger muscles, which are less well defined.

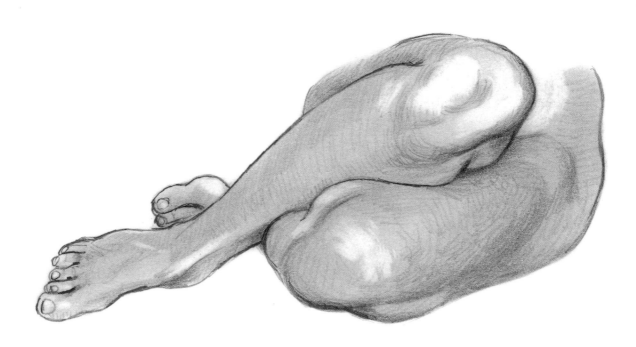

Feet

The bone structure of the foot is quite elegant, producing a slender arch over which muscles and tendons are stretched.

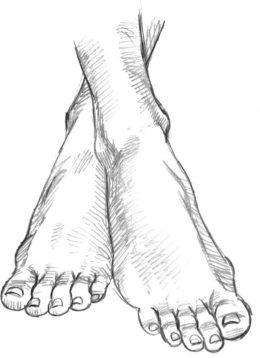

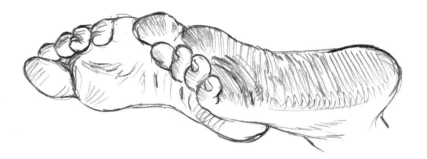

The lower part of the foot is padded with soft subcutaneous matter and thicker skin.

Notice how the toes, unlike the fingers, tend to be more or less aligned, although the smaller toes get tucked up into small rounded lumps.

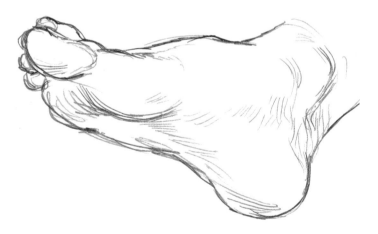

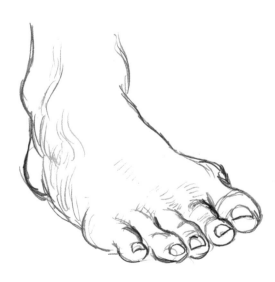

The inner anklebone is higher than the outer, which helps to lend elegance to this slender joint. If the difference in the position of the ankle bones is not noted the ankle becomes a clumsy shape. The small bump of the ankle bone is most noticeable from the front or back view but if the source of light is right it can show clearly as well from a side view.

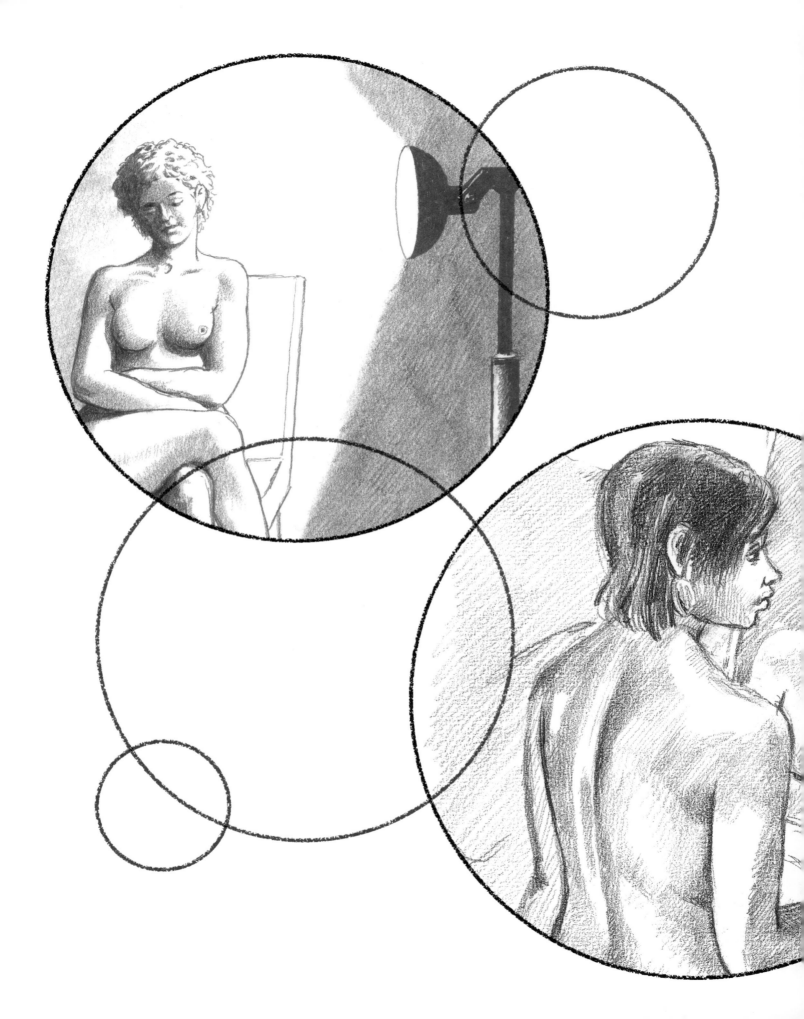

CHAPTER 2: DRAWING THE WHOLE FIGURE

Drawing the complete human body is really the subject of a life class. Generally speaking, the best you will be able to coax from friends and family is a pose in a swimming costume, since, other than the young and beautiful, most people are too self-conscious to subject themselves to such close scrutiny. You can of course draw from photographs at your leisure, but for a real understanding of the human figure, a live model is essential.

For a beginner first embarking on drawing the whole figure, the tendency is to become rather tense about the enormity of the task. The presence of a real live model, as opposed to a still-life object, can make you feel that your work may be judged and found wanting not only by your subject, but also the members of the life class that you are in. You will probably be given a time limit for poses, too, rather than being allowed to work at your leisure.

Beginners often take the slow and painstaking approach of very detailed working, which a professional would not do. So, one method you must learn is how to block in large chunks of the figure, ignoring the detail, in order to get a better idea of the whole solid mass more quickly. We shall start the chapter by looking at how you can assess the overall forms of the body and get them down on paper before beginning to add tone and dimension to your figures.

We shall also look at some of the options available to you when drawing from life: how to assess the effects of light falling over the human form; whether to include a background or setting behind your figure; and the different types of models you might be faced with.

Blocking in the Shape

Here we look at the figure as a whole and try to simplify the drawing by blocking in the main area as a simple geometric shape before engaging with the detail. You won't always have to do this, as once you are more proficient you'll be able to project it as a mental image. However, at the beginning it's sensible to draw the main shapes so that you're aware of the space that the figure occupies.

In the first figure treated thus, I've drawn a large triangle that is taller than it is wide and then marked places where I think that the shoulders, breasts and hips appear on that triangle. Putting a vertical through the centre also helps to get the feeling of the body's position.

In the second drawing the model is half reclining and again she more or less fits into a right-angled triangle with the base larger than the upright. Again I have marked in where the breasts, hips and knees should appear on this triangle to act as a check for my drawing.

38

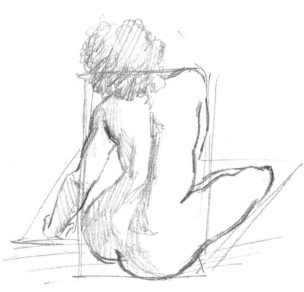

The picture of the woman sitting with her back to us is easily described in a rectangle, with two small triangles projecting out each side to contain the arm and thigh. I've let the head project outside the rectangle without any geometric shape, because the hair is curly and doesn't have a very definite shape to it.

This standing figure of a woman with hands behind her back is a simple combination of a straight line of leg, a forward bend of torso with shoulders and elbow acting as a line cutting across, and the general curve of the front shape of the figure.

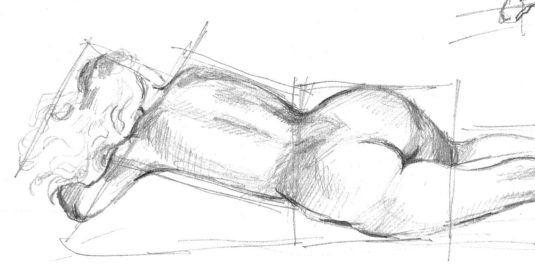

Looking at a full-length reclining figure, the first thing I noticed was the angle of the upper half in contrast to the horizontal bias of the lower part. So first I drew a square to contain the hips, buttocks and upper thighs and then a longer, narrower rectangle for the rest of the legs. For the area above the waist I drew in a quadrilateral that is uneven, but projecting at the correct angle from the central square. Above this was a vague rectangular shape that took in the head and hair. It was interesting that the base of the shape containing the upper body is about the same length as the rectangle of the legs.

A Figure in Steps

In this exercise we will start with the main shapes as before, and progress in steps to a more finished drawing, using shading to accentuate the solidity of the form. To begin with, just think in terms of simple shapes rather than visualizing a complete drawing that you may not feel capable of achieving. A drawing like this will take time, so don't forget to give your model some rest periods.

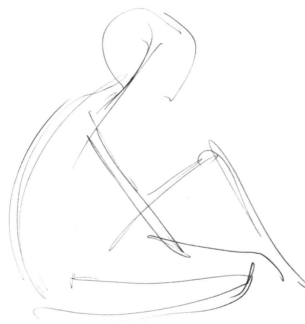

The first stage is to see the very basic shape that the disposition of the body and limbs makes in the simplest geometric way, as we did on pages 38–9. This figure is sitting with one knee up, leaning on the lower knee with the elbow of one arm. This produces a triangular shape between the torso and head and the arm and lower leg. Set against that is the additional triangle of the bent leg, which creates another triangular shape cutting into the first shape. With very simple lines, sketch in the position and proportion of the shapes.

The next stage is to make the shape more like the actual volume of the figure by drawing curved outlines around each limb and the head and torso. I have left out the original lines of the above drawing so that you can see how much there is to draw in this stage. This drawing needs to be done quite carefully as it sets the whole shape for the finished piece of work.

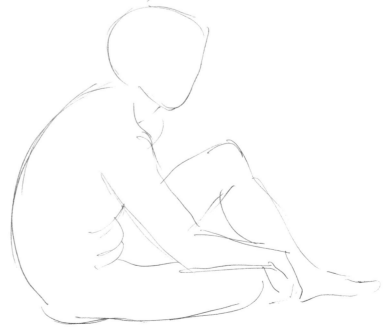

The next step is to block in the changes in the planes of the surface as shown by the light and shade on the body. This process needs only to be a series of outlines of areas of shadow and light. At the same time, begin to carefully define the shapes of the muscles and bone structure by refining your second outline shape, adding subtleties and details. Now you have a good working drawing that has every part in the right place and every area of light and shade indicated.

At this stage you will want to do quite a bit of correcting to make your shapes resemble your model. Take your time and work as accurately as you can, until you see a very similar arrangement of shapes when you look from your drawing to the model.

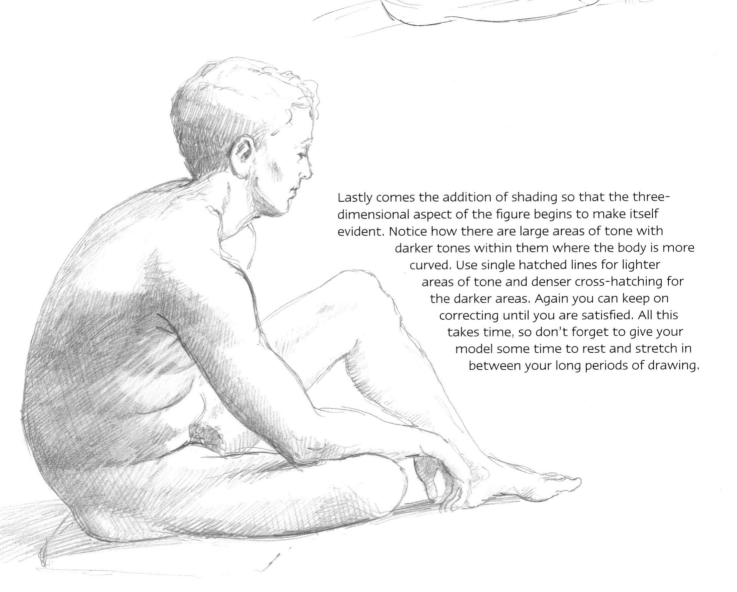

Lastly comes the addition of shading so that the three-dimensional aspect of the figure begins to make itself evident. Notice how there are large areas of tone with darker tones within them where the body is more curved. Use single hatched lines for lighter areas of tone and denser cross-hatching for the darker areas. Again you can keep on correcting until you are satisfied. All this takes time, so don't forget to give your model some time to rest and stretch in between your long periods of drawing.

Trying Different Approaches

There are many techniques that you can follow in order to improve your drawings – though there is no easy substitute for putting in hours of practice. Try the methods suggested here and familiarize yourself with them. In doing so you will begin to develop your own style and discover which method of working suits your personality best. You may find you revel in fine line drawing, or perhaps prefer to work in heavy blocks of tone.

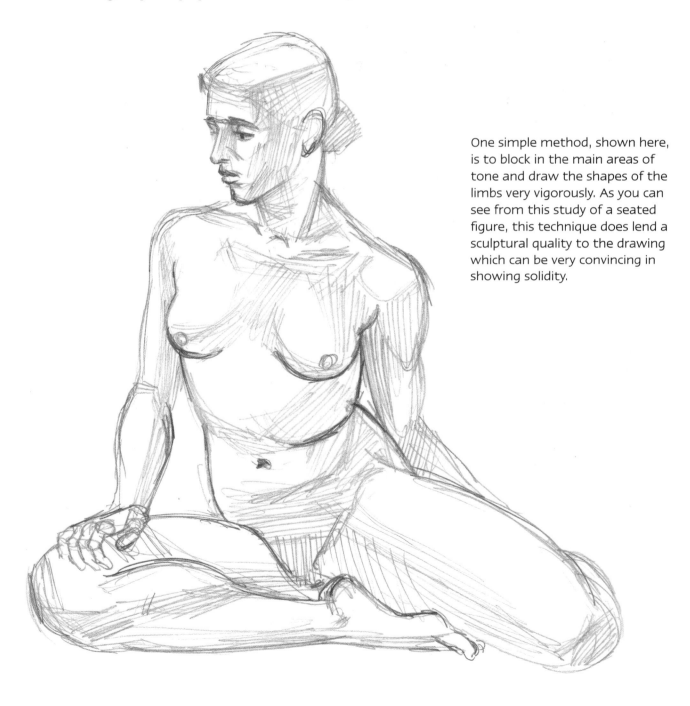

One simple method, shown here, is to block in the main areas of tone and draw the shapes of the limbs very vigorously. As you can see from this study of a seated figure, this technique does lend a sculptural quality to the drawing which can be very convincing in showing solidity.

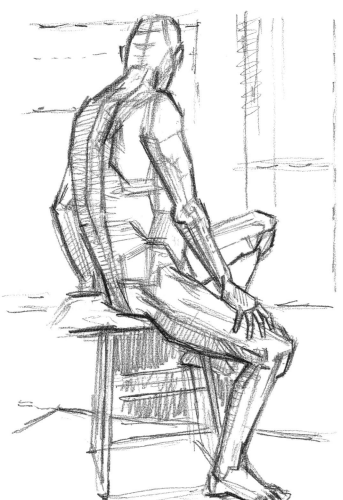

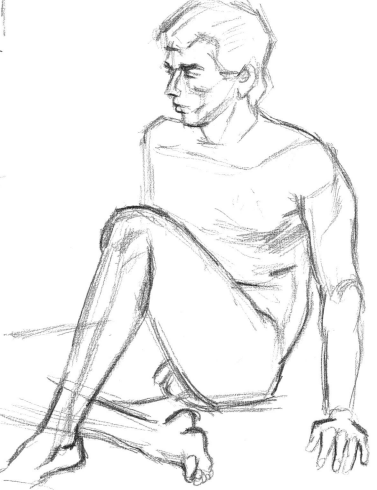

Taken a step further, this block shading approach gives the effect of a figure carved in wood or stone with hard edges defining each facet of the bodily form. This method helps give depth and strength to your figure drawings, although you sacrifice subtlety in the process. It can work better with a chunky or hard-looking body than it does with a more rounded form.

This example is not so chunky and some curves are visible, but nevertheless the main point is that it produces an impression of the bulk of the form, using very little in the way of detail.

In the drawings on this page the form of the body is clearly defined by the use of tone, but without much variation in the tone. A thick graphite pencil is used to shade large areas of tone, leaving just a few highlights. The resulting drama of the light areas contrasting with the darker shadowed areas makes for an effective method to show form.

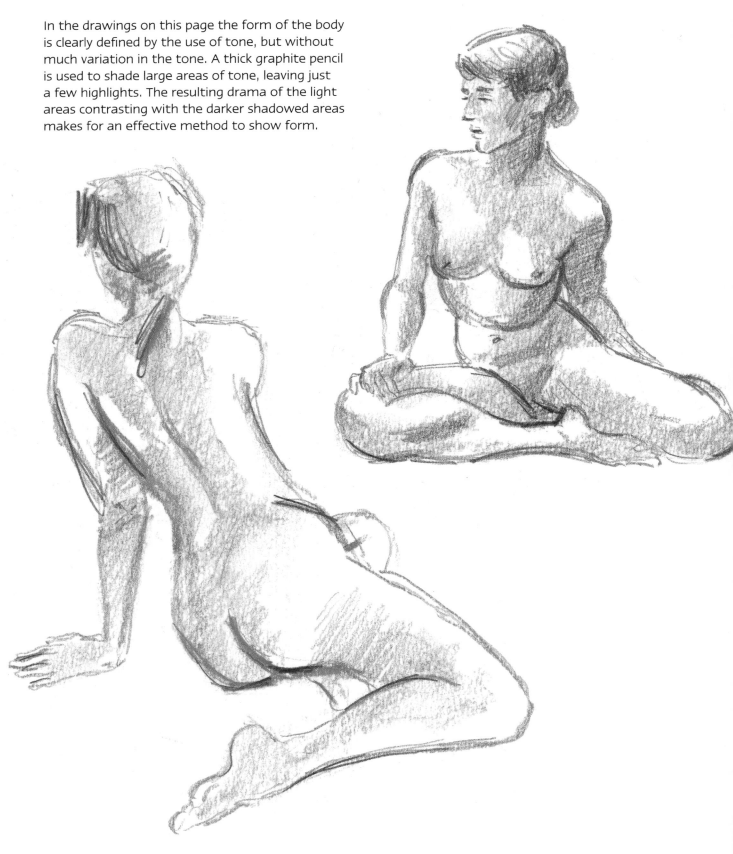

Another approach is to leave out tone altogether and draw your model's pose fairly simply from more than one angle. Therefore, if the model is sitting facing you, make a simple but effective outline sketch then move round to the side or the back in order to draw the same pose from as many different angles as you think fit. What this does is to help you to see the pose more clearly. Although you may have to do these sketches quite fast, when you come to draw from one point of view in more detail the knowledge you have gained about the model's pose and shape will inform your work, so that you will probably produce a much more accurate version of the pose.

Lighting the Model

In order to make your drawing work more effectively it is necessary to take into consideration the way the light falls onto the figure. Natural light is the norm in life drawing, except in winter when it may not be available for sufficient hours in the day. Most artists' studios have north-facing windows because they give light without the harsh shadows caused by sunshine. With north light the shadows tend to be even and soft, showing small graduations in tone very clearly so that the changes of surface direction can be easily seen.

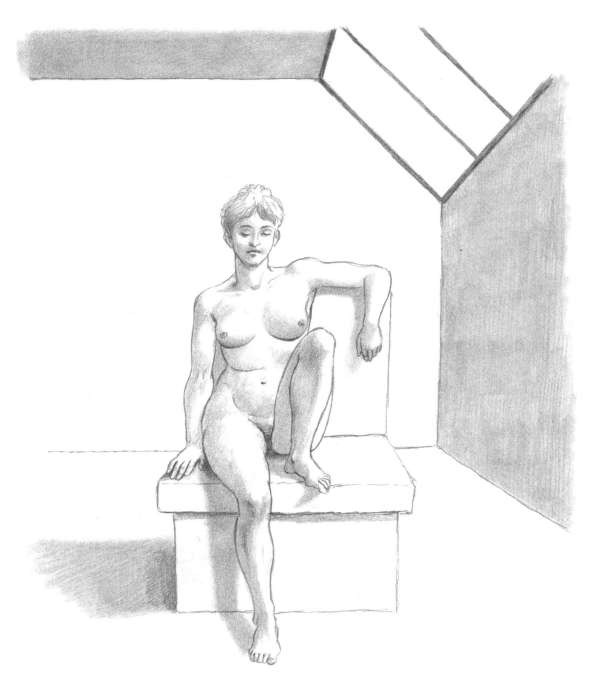

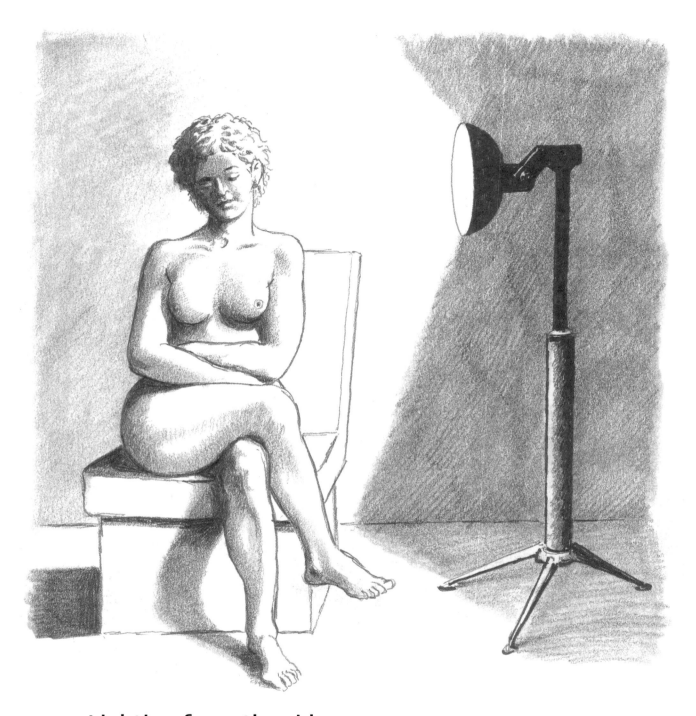

Lighting from the side

This picture gives a clear indication of how strong directional light results in harsh shadows and very brightly lit areas. This can produce very dramatic pictures: the Italian artist Caravaggio, for example, was known to have had massive arrays of candles to light his models in order to produce his very dramatic contrasts in light and shade, known as *chiaroscuro*.

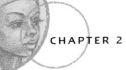

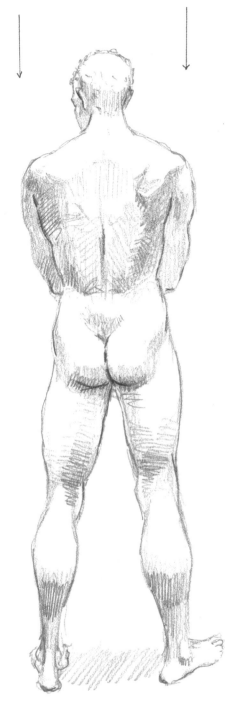

Lighting from above and below

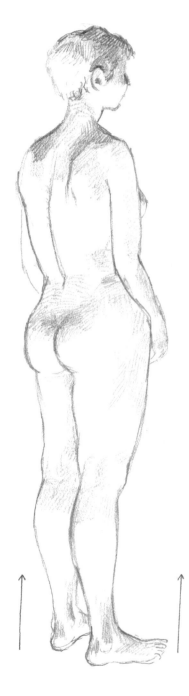

Lighting from below is very unusual and looks rather unnatural. The calves, buttocks and middle back get most of the light, but it also falls on the back of the head and, at the front, the lower belly, ribcage and breasts. There is also a lot of light under the chin, which gives a rather ghostly look. This kind of dramatic lighting from below was often used for the demonic characters in old horror films.

Light from directly above the model has a very strong dynamic, but when the model is standing heavy shadows form under the shoulder blades and down the length of the back, under the buttocks and on the lower thighs and calves of the legs. Light coming only from above does not occur frequently, so the standing figure will also look unfamiliar. When the model is lying down the effect is not quite so dramatic and looks more natural.

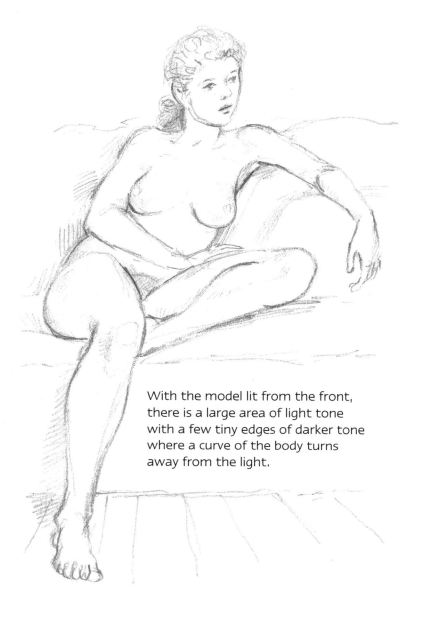

With the model lit from the front, there is a large area of light tone with a few tiny edges of darker tone where a curve of the body turns away from the light.

Front and back lighting

Light sources coming from behind or in front of the model present the most difficult challenge to the artist in terms of drawing the form and substance of the figure. When the light is directly in front of the model the effect is to flatten the form so that the obvious planes of light and shade tend to disappear into the overall light tone. Consequently, this lighting will result in a drawing that is more of an outline, with just a few subtle tonal areas shown. Lighting from behind has a similar effect, but in reverse. This time the only area with light shining on it is the edge of the form – usually the top edge.

In this reclining model I have depicted slightly more line along the edge than you might see when the drawing is entirely *contre jour* (against the light) so that it is easier to understand the point. Sometimes you might only see an outline silhouette with bright light all around. The effect is exactly the opposite of frontal lighting in that the large area is of a dark tone with light edges appearing where the light hits. With both types of lighting the outline drawing is the key, so it is important to get the outline shape as accurate as is possible.

Drawing the Model in a Setting

When you come to draw a complete human figure, whether from a live model or not, you will need to decide how to deal with the paper around the figure, and whether or not to include a background. The two examples shown here are done in a fairly classical style, but whereas the one on the left is set in a sort of limbo with no background around it, the other is placed in a real-life setting, which is a London art studio. So, in the first drawing there are no outer marks, no points against which to measure the body shape. In the second, there are the chair, the vertical lines and the shelves in the background, which all help to establish the position of the figure.

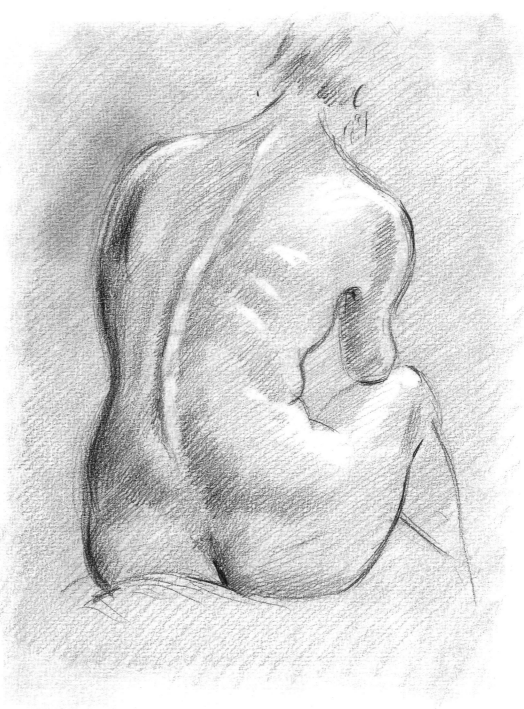

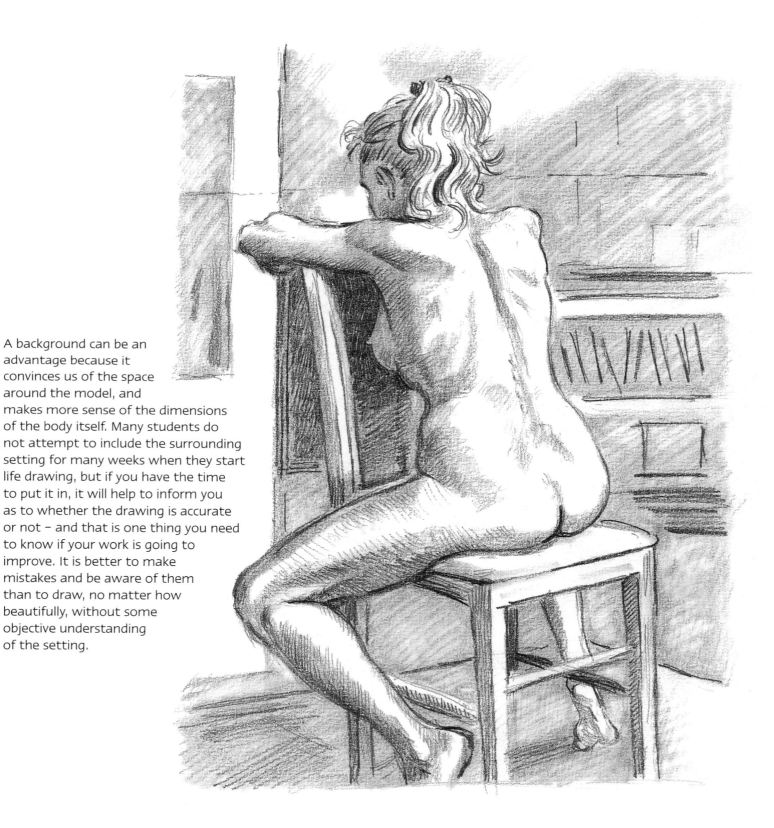

A background can be an advantage because it convinces us of the space around the model, and makes more sense of the dimensions of the body itself. Many students do not attempt to include the surrounding setting for many weeks when they start life drawing, but if you have the time to put it in, it will help to inform you as to whether the drawing is accurate or not – and that is one thing you need to know if your work is going to improve. It is better to make mistakes and be aware of them than to draw, no matter how beautifully, without some objective understanding of the setting.

Drawing the Same Model

When you draw the same model from different angles at different times you gradually become accustomed to the construction of that particular body.

This is very useful, especially if your drawings are all done fairly close together in time. You begin to recognize the particular shapes and proportions of your model, which helps you to identify the different parts of the body more easily.

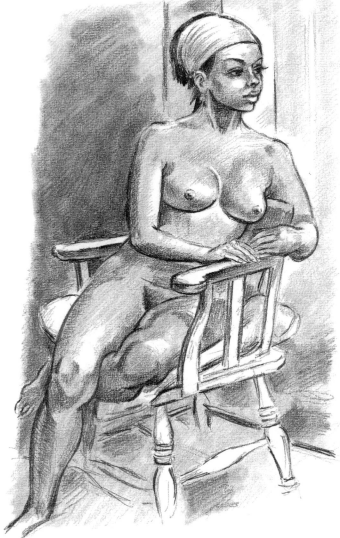

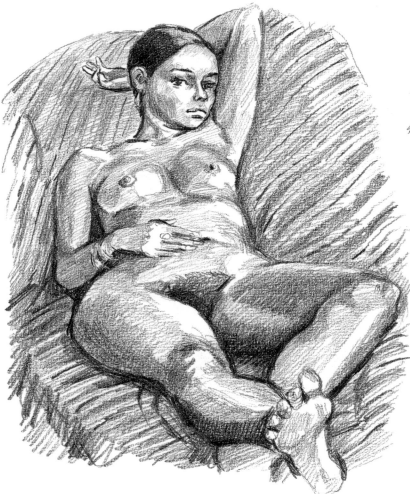

Here are three studies of one of my favourite models, a Brazilian woman much in demand for life classes. These poses show her from the front sitting in a chair; from the foot end, reclining; and sitting with her back to me but reflected in a mirror. These three drawings and several others have enabled me to get a very clear idea of her body structure, and how the muscles work on the skeleton.

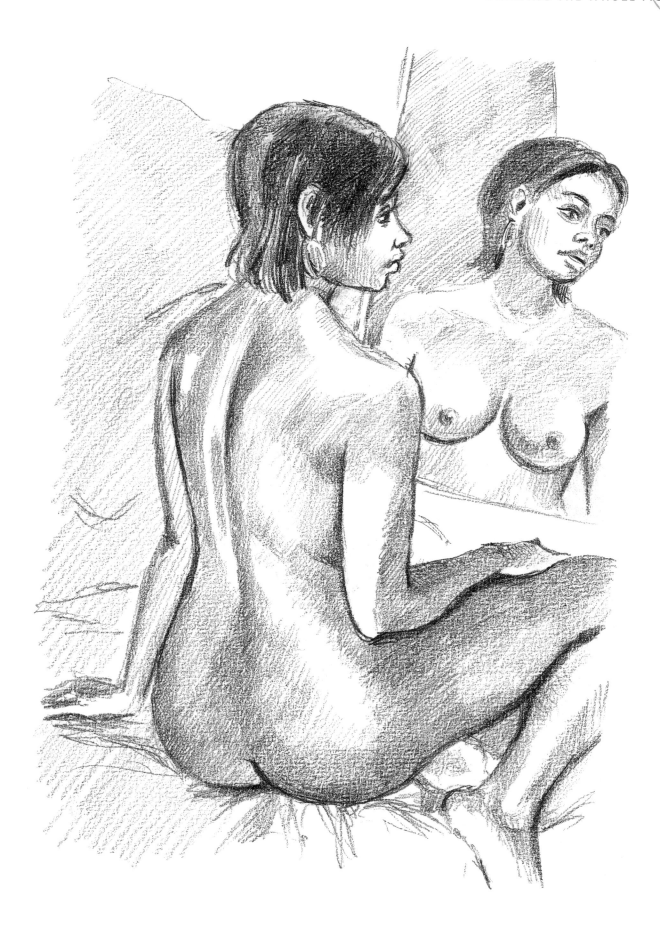

Different Shapes and Sizes

When you go to a life class, you will discover that the models are vastly different in build. What they will look like is anybody's guess, not least because art tutors seem to delight in booking models of as many different shapes and sizes as possible.

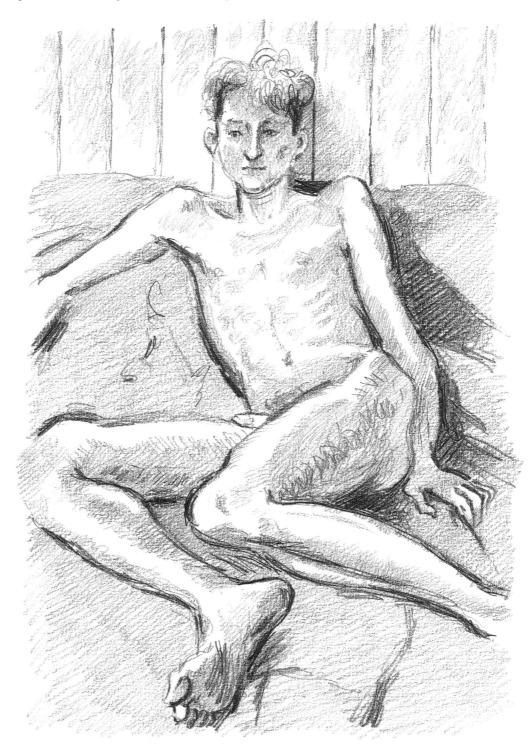

As with our first example, you might get a young man who is skinny and angular, so that the skeleton beneath the muscles is very much more obvious than in an average figure. This means that you get plenty of practice in drawing bone structure but the muscles are harder to make out.

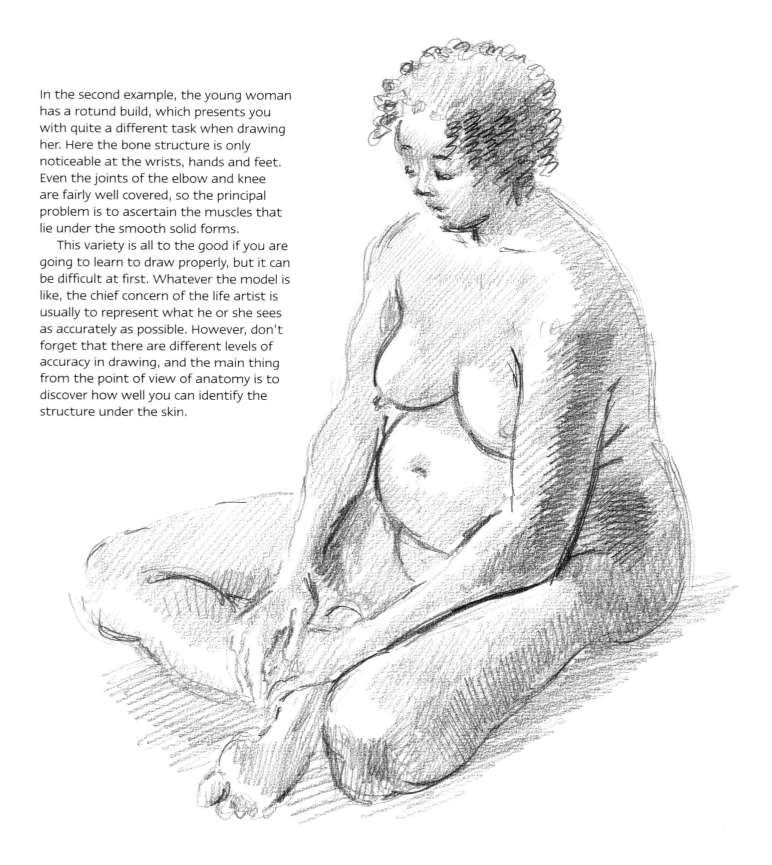

In the second example, the young woman has a rotund build, which presents you with quite a different task when drawing her. Here the bone structure is only noticeable at the wrists, hands and feet. Even the joints of the elbow and knee are fairly well covered, so the principal problem is to ascertain the muscles that lie under the smooth solid forms.

This variety is all to the good if you are going to learn to draw properly, but it can be difficult at first. Whatever the model is like, the chief concern of the life artist is usually to represent what he or she sees as accurately as possible. However, don't forget that there are different levels of accuracy in drawing, and the main thing from the point of view of anatomy is to discover how well you can identify the structure under the skin.

CHAPTER 3: DEVELOPING FORM AND MOVEMENT

In this chapter we shall look at how to develop your drawings of nude figures a step further, considering different techniques for conveying form. One of the greatest problems for artists is the need to indicate the three-dimensional qualities of the body on the flat paper surface. There is no fixed methodology for this and experimenting with different approaches will help to build your confidence and skill.

Another challenge that you will encounter when you draw from life is how to show the figure in perspective, with foreshortening of parts or all of the body. We all invariably have preconceived ideas about what the human body looks like and often this can stop us from observing accurately what we have in front of us. Every artist, however professional, knows that when they start to draw from life, dropping these ingrained ideas is essential.

Once you have begun to produce drawings that look like convincing pictures of human beings you will soon want to have a go at drawing figures in more mobile or unusual poses. Artists are helped a lot by photographs which have caught the mobile figure and show us how the movement breaks down into its various parts, and by videos that can be freeze-framed. Nothing quite takes the place of quick sketches of your model moving about, perhaps slowly performing the action you want to study. Observation is the key to drawing movement; noticing how the body's balance changes, how the weight shifts and how the arms and head move. We shall consider some more active bending and stretching poses, as well as looking at the sort of lines or marks you make in order to give the effect of a moving body.

Describing Form

Here I show two very different approaches to describing the form of the figure: on the left the classic method of shading in pencil and on the right a more experimental approach using fine hatching and dotting in fine-liner pen. Both methods are effective, but the pencil gives a more subtle, softer-looking result, while the pen drawing has a graphic quality.

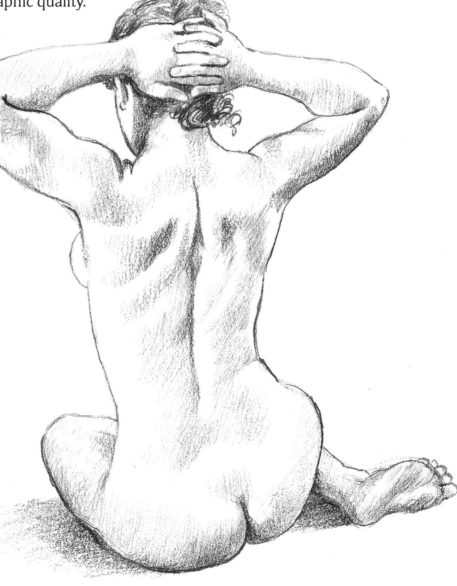

The first example shows the classic method of shading in pencil, which the majority of artists use at some time or another, and it is probably one of the most effective methods of showing solidity. What artists rely upon here is the fact that we cannot see anything without sufficient light both to illuminate one surface and throw another in the shade. Traditionally, the way to illustrate light and shade is to move your pencil across the paper in regular, close-set lines to affect an area of shadow. This has to be done in a fairly controlled way and the better you become at it, the more convincing is the result. Leonardo da Vinci was famous for laying on shadow in this way, using a technique called *sfumato*, meaning that the result was so subtle and soft that the gradation of tone looked almost like smoke. While our example doesn't claim to be as expert as Leonardo's, nevertheless you can see how by very careful progression with the shading, the impression of a solid body with the light falling on it from one side is convincing, and gives roundness to the limbs and torso of the model. We shall look further at pencil techniques on pages 78–81.

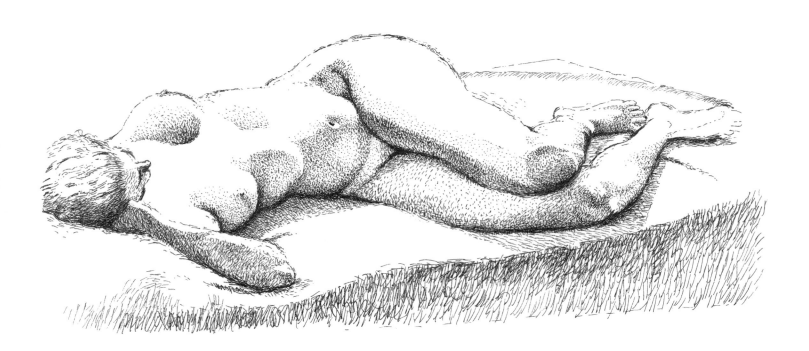

The next study is quite different in technique, executed with a graphic fine-liner pen. This is a daring thing to do if you are a beginner, because every mark you make is obvious, and it is not possible to erase in the normal way. But if you persevere with your studies, it is in fact a very good way to draw, as it makes you more aware of your imperfections and also, as you improve, it gives you the confidence to make mistakes without cringing when others see them. A word of warning, however: it is extremely time-consuming, so you will need a good long pose, or a photograph to refer to. We shall consider more techniques with pen and ink on pages 82–4.

Expressing Volume

Showing the volume of the figure will make your drawings convincingly solid. You can make a small figure appear weighty by blocking in areas of tone, a technique used by artists when the drawing is to be painted as it clarifies how the area of tone and colour should be handled. Contour lines also give the impression of the roundness of the head and body.

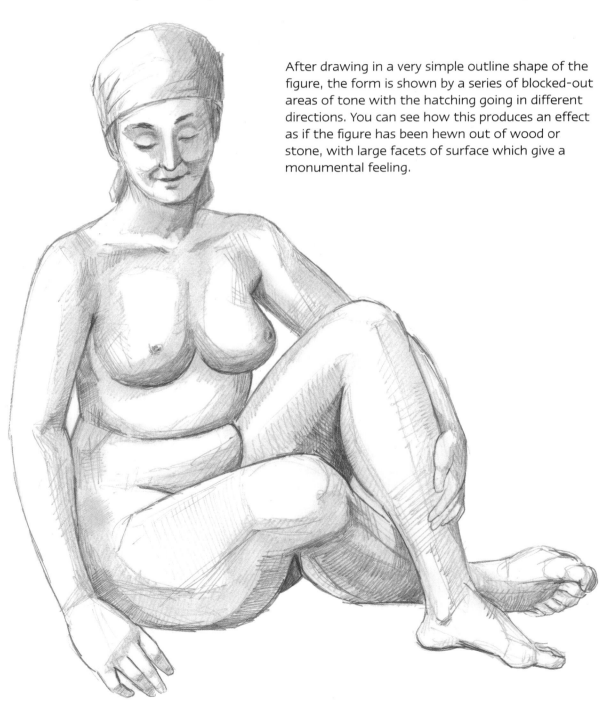

After drawing in a very simple outline shape of the figure, the form is shown by a series of blocked-out areas of tone with the hatching going in different directions. You can see how this produces an effect as if the figure has been hewn out of wood or stone, with large facets of surface which give a monumental feeling.

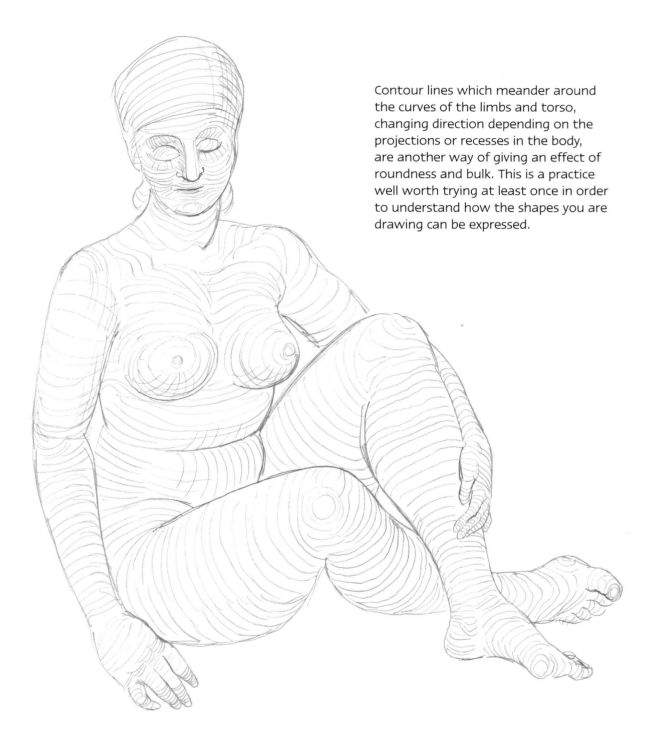

Contour lines which meander around the curves of the limbs and torso, changing direction depending on the projections or recesses in the body, are another way of giving an effect of roundness and bulk. This is a practice well worth trying at least once in order to understand how the shapes you are drawing can be expressed.

Hard and Soft Lines

Even in a line drawing with no attempt at tone you can influence the way the viewer will see and understand your figure. Producing a hard, definite line requires a steadier nerve on the part of the artist than a softer, more tentative line, but both are an equally valid way of describing the human form and lending feeling to the image.

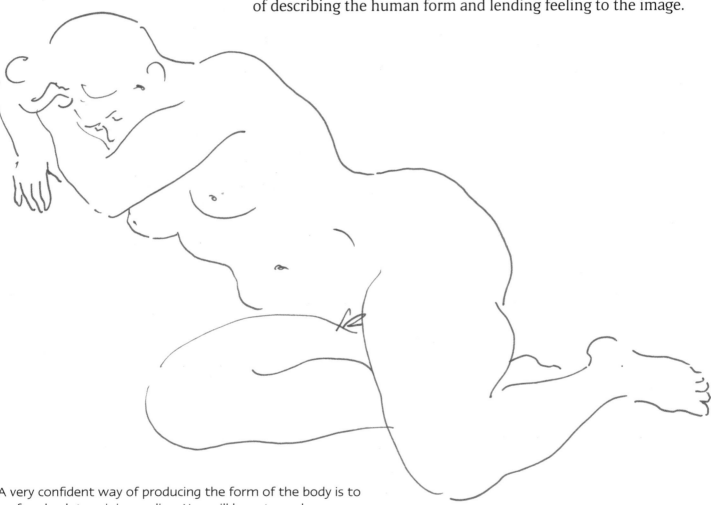

A very confident way of producing the form of the body is to go for absolute minimum line. You will have to make up your mind about a whole passage of the figure and then, as simply and accurately as you can, draw a strong, clear line without any corrections to produce a vigorous, clearly defined outline shape. Only the very least detail should be shown, just enough to give the effect of the human figure you see in front of you. This requires a bold approach and either works first go or not, but of course you can have as many shots at it as you have time for. It really teaches economy of both line and effect and also makes you look very carefully at the figure.

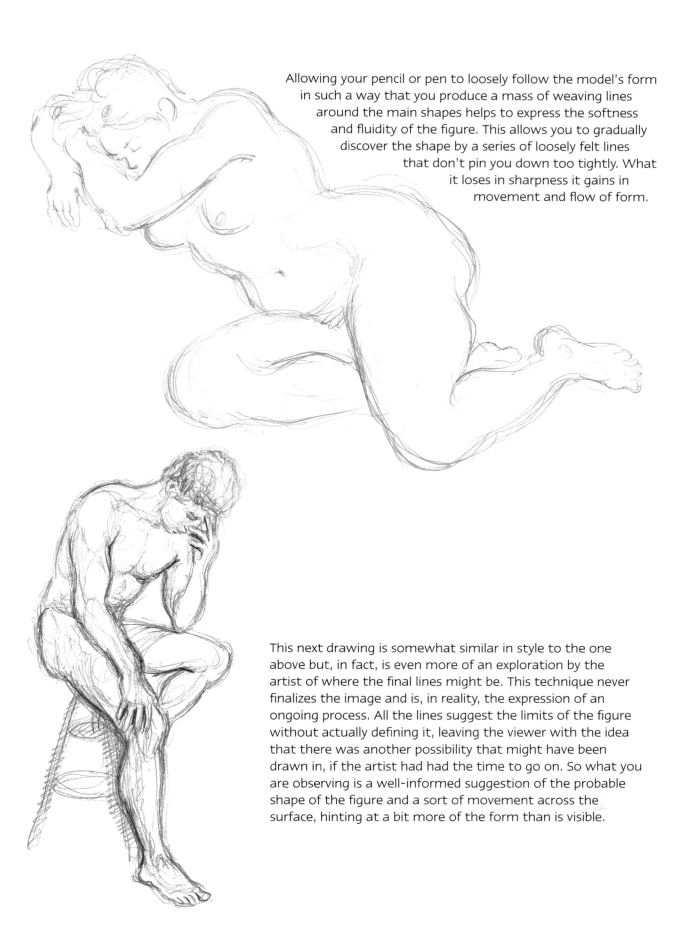

Allowing your pencil or pen to loosely follow the model's form in such a way that you produce a mass of weaving lines around the main shapes helps to express the softness and fluidity of the figure. This allows you to gradually discover the shape by a series of loosely felt lines that don't pin you down too tightly. What it loses in sharpness it gains in movement and flow of form.

This next drawing is somewhat similar in style to the one above but, in fact, is even more of an exploration by the artist of where the final lines might be. This technique never finalizes the image and is, in reality, the expression of an ongoing process. All the lines suggest the limits of the figure without actually defining it, leaving the viewer with the idea that there was another possibility that might have been drawn in, if the artist had had the time to go on. So what you are observing is a well-informed suggestion of the probable shape of the figure and a sort of movement across the surface, hinting at a bit more of the form than is visible.

Figures in Perspective

Once you feel more confident with drawing conventional sitting and standing poses, you are ready to tackle the bigger challenge of seeing the figure in perspective where the limbs and torso are foreshortened.

To examine this at its most exaggerated, the model should be lying down on the ground or a low platform or bed. Position yourself so that you are looking from one end of the body along its length and you will have a view of the human figure in which the usual proportions are all changed. Because of the laws of perspective, the parts nearest to you will look much larger than the parts farther away.

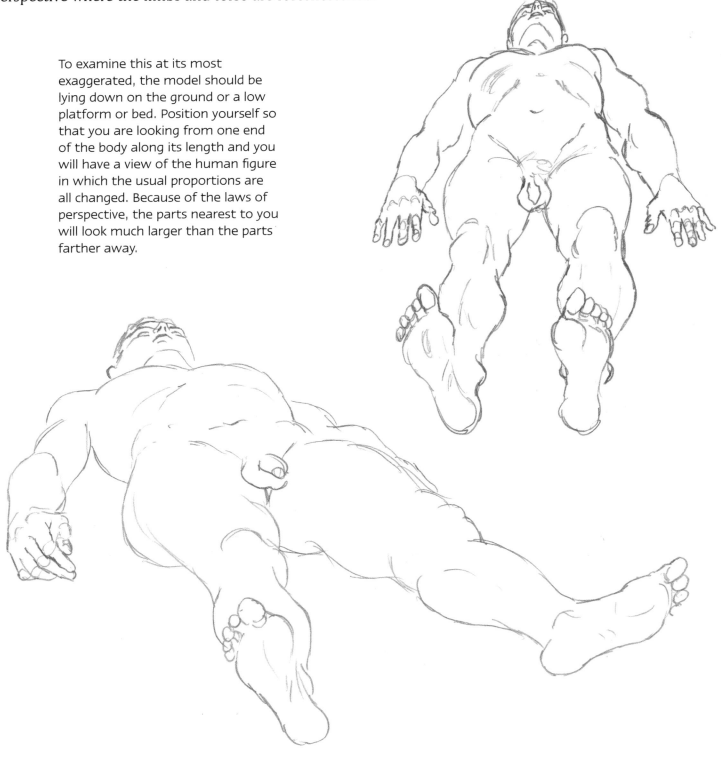

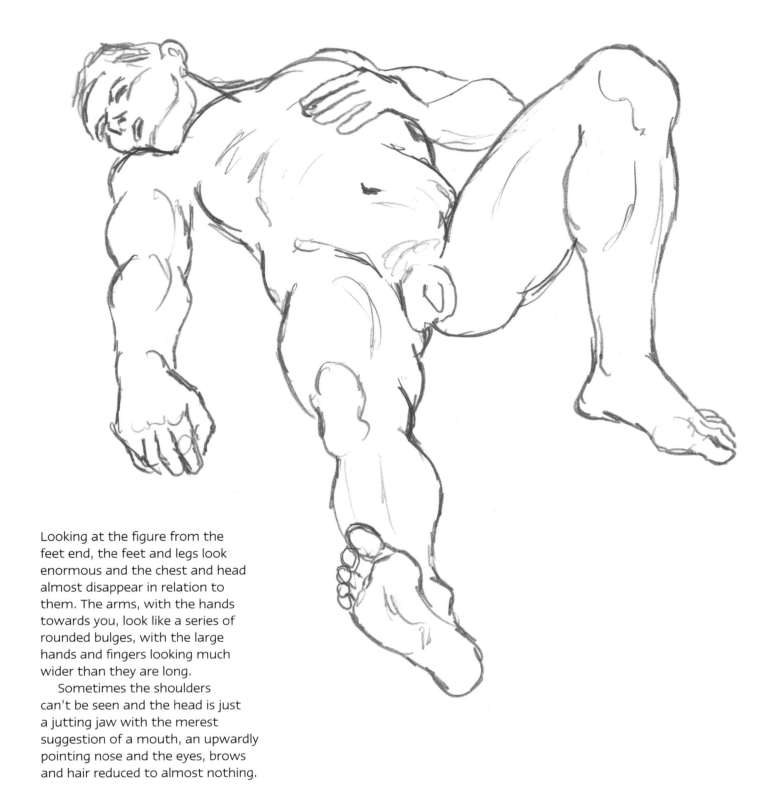

Looking at the figure from the feet end, the feet and legs look enormous and the chest and head almost disappear in relation to them. The arms, with the hands towards you, look like a series of rounded bulges, with the large hands and fingers looking much wider than they are long.

Sometimes the shoulders can't be seen and the head is just a jutting jaw with the merest suggestion of a mouth, an upwardly pointing nose and the eyes, brows and hair reduced to almost nothing.

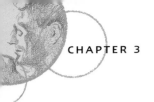

Changing Ends

Standing at the head end, you will find that everything has to be reassessed again. This time the head is very large but you can mostly see just the top of it and the shoulders and chest or shoulder blades, which bulk large.

As the eye travels down towards the legs, the most noticeable thing is how short and stubby they look from this angle. The feet may stick up if the model is on his or her back, but the legs themselves are just a series of bumps of thighs, knees and calves.

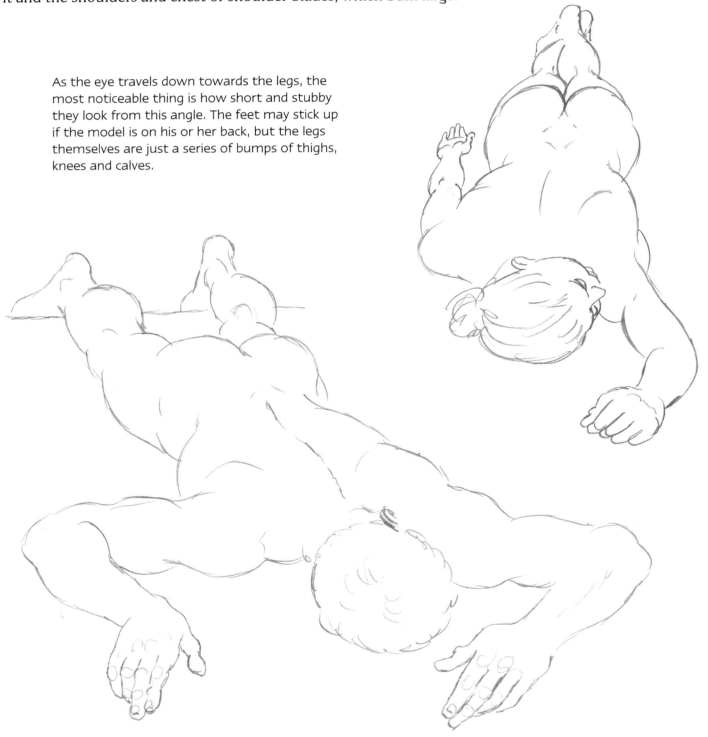

Try measuring the difference between the legs and the torso and you will find that although you know the legs are really half the length of the whole figure, from this angle they are more like a quarter of the full length. Not only that, the width of the shoulders and hips is vastly exaggerated so that the body looks very short in relation to its width. Most students new to this view of the figure draw it far too long for its width because they have in their mind the proportions of how the figure looks when standing up. Make sure you observe the figure carefully to avoid this.

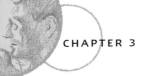

Active Poses: Speed Drawing

These figures show the effect of turning, swinging and stretching movements on the body. Such dynamic poses can be quite difficult for a model to hold so you have to be quick to get them down or rely on photography. My drawings were all completed in one to five minutes, and you can see how the time restraint forces you to draw instinctively and can contribute to the sense of movement in the figure.

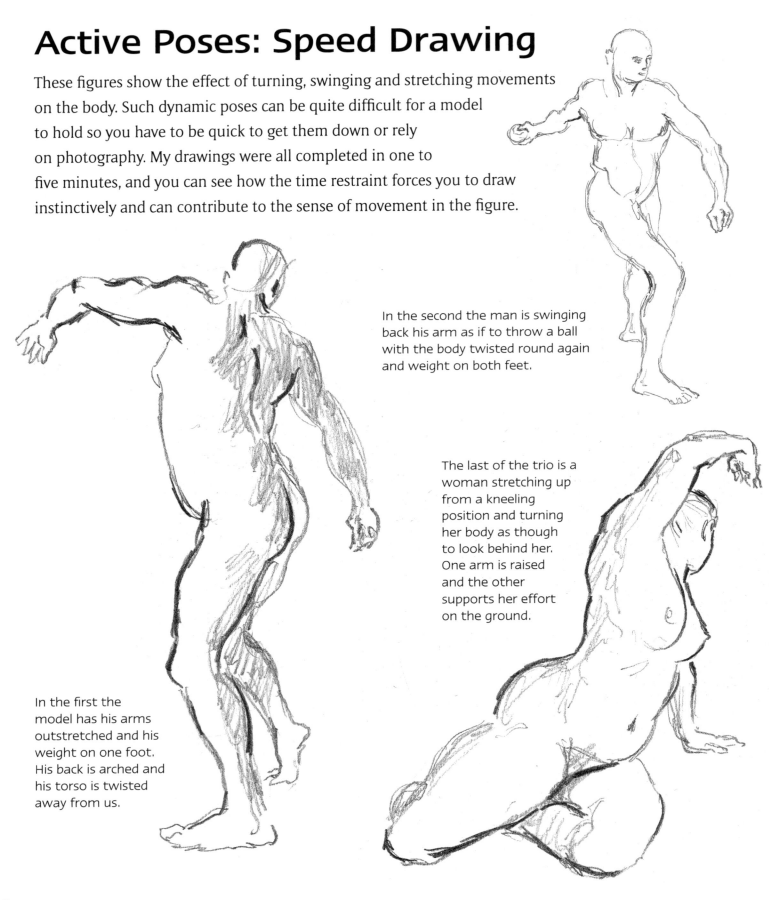

In the second the man is swinging back his arm as if to throw a ball with the body twisted round again and weight on both feet.

The last of the trio is a woman stretching up from a kneeling position and turning her body as though to look behind her. One arm is raised and the other supports her effort on the ground.

In the first the model has his arms outstretched and his weight on one foot. His back is arched and his torso is twisted away from us.

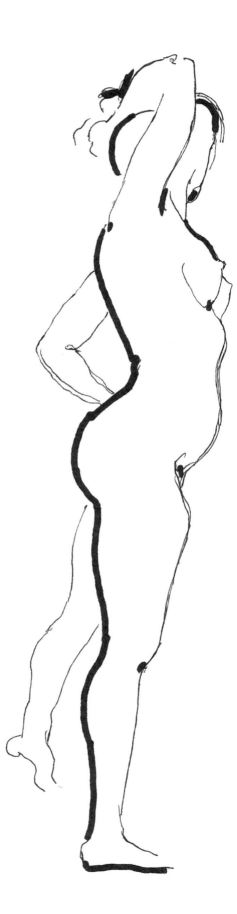

These drawings were completed with a minimum of line to capture the stretching movement of the figures. I accentuated the forms with some strokes of a felt-tip pen to give the drawings more vigour.

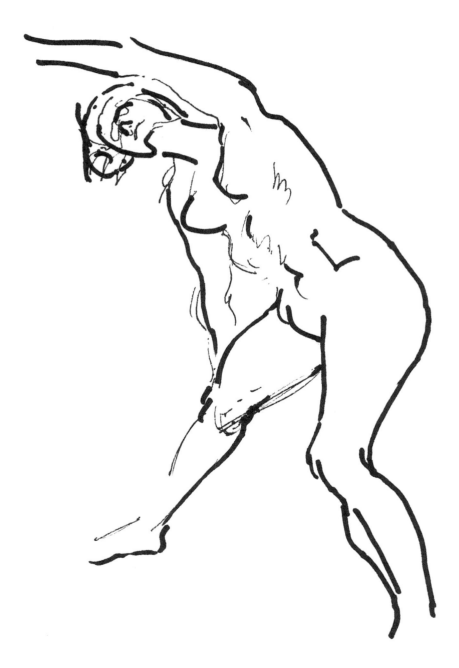

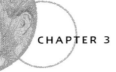
Bending and Stretching

The next drawings show models bending and stretching, which, although not a very energetic movement, does bring many of the muscles into play.

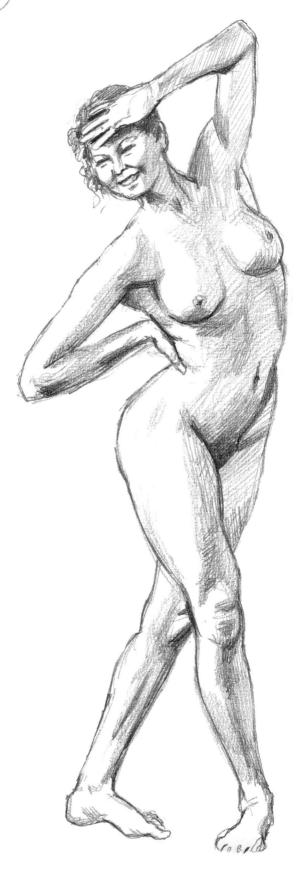

The standing model is stretching her torso down one side and has placed her feet in such a way as to make her legs turn in different directions. The seated woman bending sideways is stretching her thigh muscles as well as all of the muscles down one side of her torso.

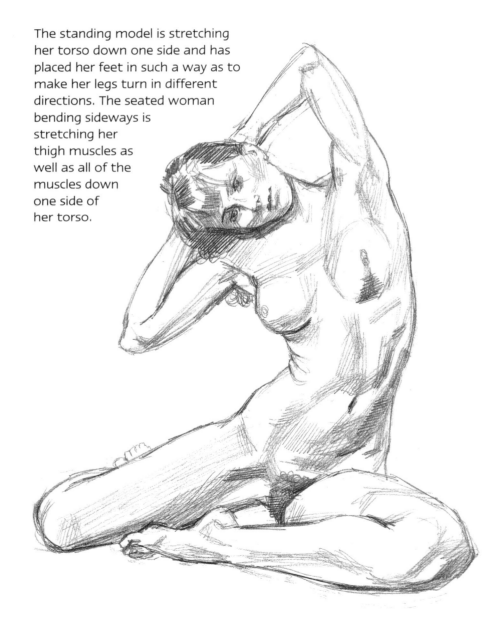

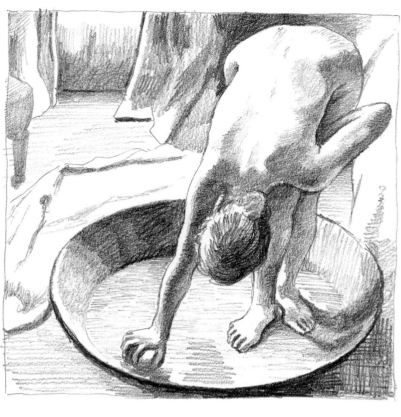

The view taken here by the French Impressionist Edgar Degas (1834–1917) is quite extraordinary. We see the upper part of the woman, upside-down as she bends to pick up a sponge. This is an unusual view of quite a simple action and gives an interesting dynamic to the overall composition. Of course a model cannot hold a pose like this for long and will need to take regular breaks.

The model sitting cross-legged and stretching her arms above her head is showing very clearly her ribcage and her knee joints.

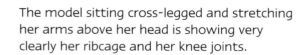

Masters of Movement

The two artists featured here were both masters of drawing the human figure. Ingres (1780–1867) doesn't define the muscles very sharply, preferring a smoother overall look to his figures with an emphasis on the outline forms. The drawings of Otto Greiner (1869–1916) show a high level of detail in the depiction of the muscles, resulting in a rippling effect across the surface of the body.

This study by Ingres shows a man lifting a chair above his shoulder as he walks forward. The arm muscles are particularly obvious as they are bearing the weight of the chair. The second drawing shows a man reaching down to lift something from the ground. The stretching of the legs and arms brings into play all the muscles of the limbs and torso. As happens in many life drawings by accomplished artists, Ingres has drawn extra definitions of the feet in the standing pose and the stretched arm in the drawing below. These workings help to clarify what is actually happening in a complex part of the pose.

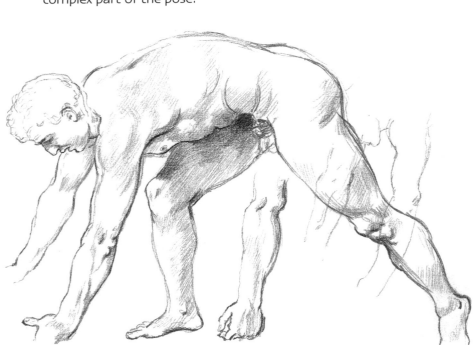

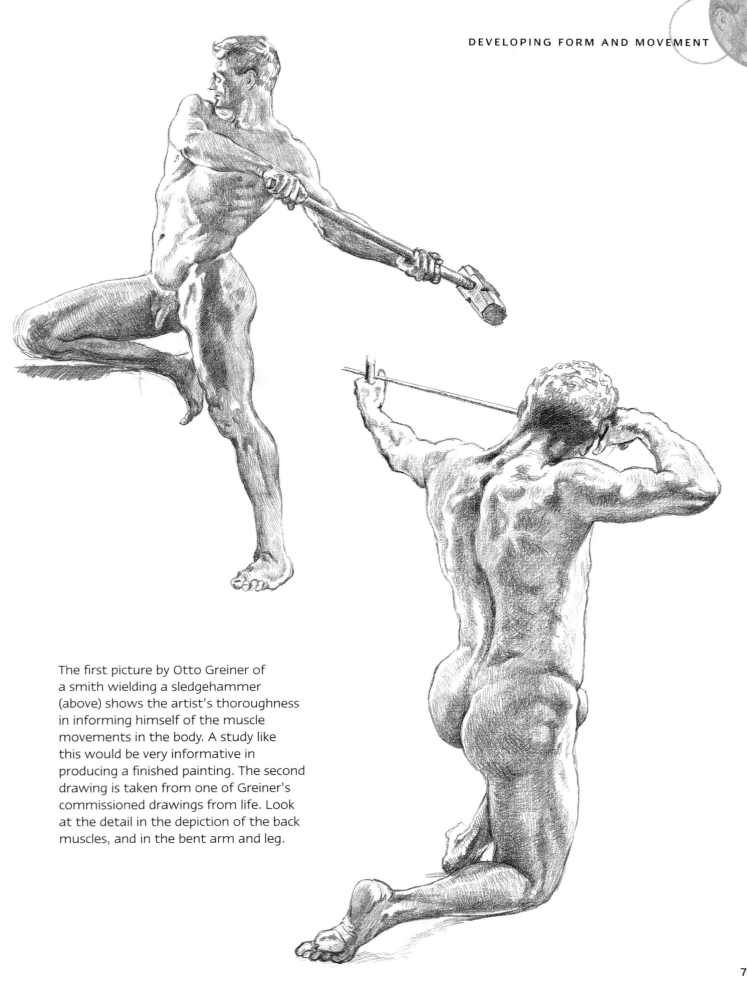

The first picture by Otto Greiner of a smith wielding a sledgehammer (above) shows the artist's thoroughness in informing himself of the muscle movements in the body. A study like this would be very informative in producing a finished painting. The second drawing is taken from one of Greiner's commissioned drawings from life. Look at the detail in the depiction of the back muscles, and in the bent arm and leg.

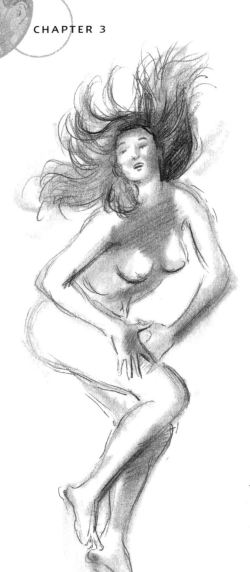

Form in Movement

Now let us explore what happens when trying to show the human body in motion, which is by no means easy considering that you are working on a static image. Even so, artists have always found ways of conveying the idea of movement and there are several stratagems designed to bring action drawings to life.

The drawing on the left uses two artistic devices, one of which is based on a photographic technique. When photographing a moving figure at a slow shutter speed, the result is a deliberate blur. In this drawing, the artist has blurred the form significantly in order to produce the same effect. Not only that, he has chosen a pose that, from the positions of the legs and arms, suggests that the model must be jumping in the air; hair does not look like this otherwise, and even the expression on her face adds to the illusion.

This drawing takes the blurring technique to the stage where the figure hardly looks real at all, except as an expression of movement through space. The oblique lines with which the figure is drawn have the effect of making the viewer aware of movement and nothing else. One can tell it is a man but not any details about him, except that he can jump.

The next drawing is much more obvious in its method. Using the technique of an undulating and multiformed line to encompass the figure, the pose is vigorous enough to give the impression of a woman dancing. So, by means of this slightly unfinished look, the artist conveys the feeling of something still under observation – not yet a finished product. This gives the viewer the impression that the figure is unresolved owing to its movement in space and time.

DEVELOPING FORM AND MOVEMENT

Dancing Figures

The figures here show what happens when the body is projected off the ground with necessary vigour.

The woman in a ballet leap has extended her legs as far as she can in both directions, pointing her toes, arching her back with her arms extended and her head back, creating a typical dance pose in mid-air.

This drawing of a leaping man shows how his left leg is bent as much as possible while his right leg is extended. His torso is leaning forward, as is his head, and his arms are lifted above his shoulders to help increase his elevation.

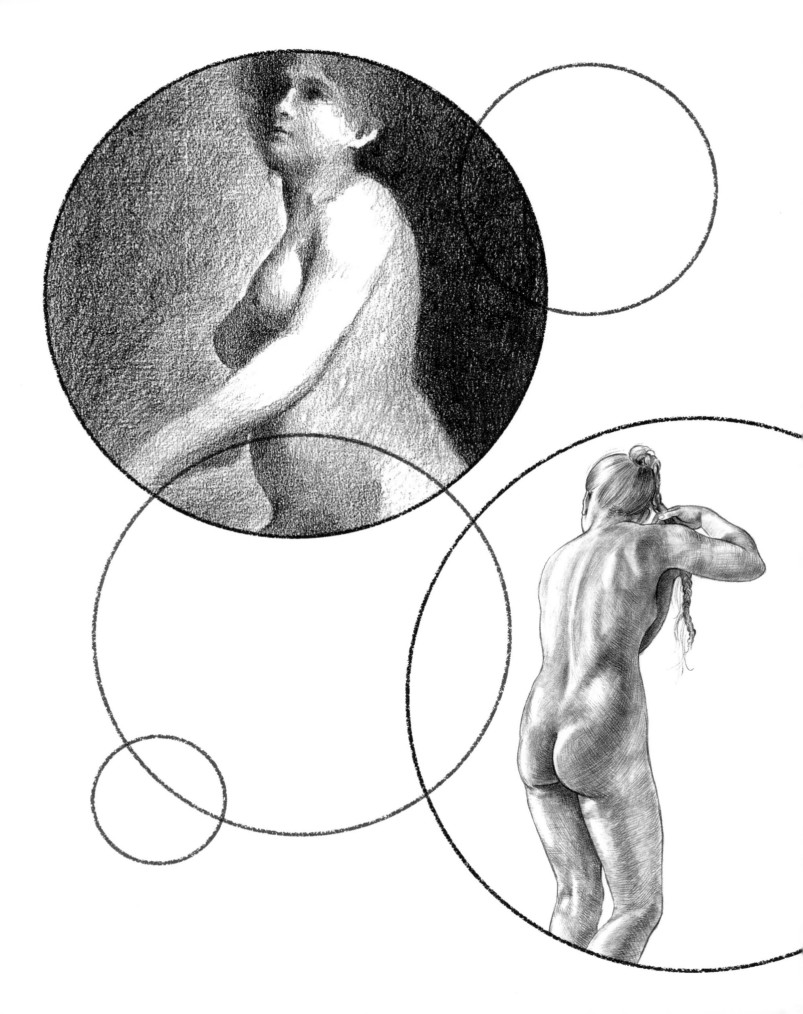

CHAPTER 4: TECHNIQUE AND COMPOSITION

When you study figure drawing your first aim is to build up your understanding of how the human body looks so that you can depict its form successfully. However, there will come a time when you will want to develop an individual style and method of working. To do this, you need to experiment with the wide range of materials and implements available. In this chapter, we look first at different implements and the effects that can be achieved with them, including pencil, pen and ink, line and wash, and chalk on toned paper. We shall look at approaches to the art of drawing the nude figure taken by different artists at different times.

If you want your figure drawing to be seen as a completed picture you will need also to consider the overall composition. Bringing composition into the equation requires a slightly different approach to your drawing. First, looking at the model in front of you, you should make sure he or she is in exactly the pose you wish to draw and whether your own position gives you the viewpoint you want. Next, consider how the shape that you see will be placed on the paper. Will it take up all of the space or just some of it? The process becomes more complex when there is more than one figure to place in the picture, as you will have to consider their relationship to each other and how they will fit into the designated space. We shall look at some techniques for developing your compositions and consider how master artists have approached more complex groups of figures.

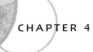

Pencil

Pencil can be used in many ways. When it was invented – some time in the 16th century – it revolutionized artists' techniques because of the enormous variety of skilful effects that could be produced with it, and soon came to replace well-established drawing implements such as silverpoint.

The production of pencils in different grades of hardness and blackness greatly enhanced the medium's versatility. Now it became easy to draw in a variety of ways: delicately or vigorously, precisely or vaguely, with linear effect or with strong or soft tonal effects.

Here we have several types of pencil drawing, from the carefully precise to the impulsively messy, from powerful, vigorous mark-making to soft, sensitive shades of tone.

The High Renaissance artist Michelangelo (1475–1564) is a good starting point for ways of using pencil, although his own drawings were made prior to the invention of pencils. His work was extremely skilful and as you can see from this drawing his anatomical knowledge was second to none. The careful shading of each of the muscle groups in the body gives an almost sculptural effect, which is not so surprising when you consider that sculpture was his first love. To draw like this takes time and patience and careful analysis of the figure you are drawing.

The Venetian artist Titian (c.1490–1576), although working at the same time as Michelangelo, had a quite different style. He is obviously feeling for texture and depth and movement in the space and is not worried about defining anything too tightly. The lines merge and cluster together to make a very powerful tactile group.

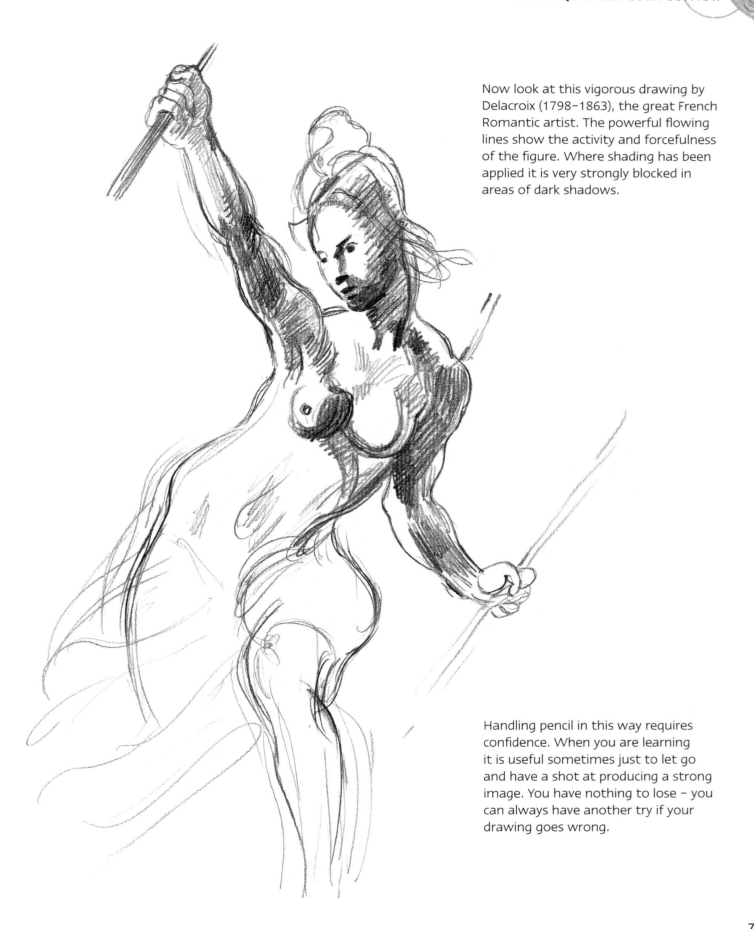

Now look at this vigorous drawing by Delacroix (1798–1863), the great French Romantic artist. The powerful flowing lines show the activity and forcefulness of the figure. Where shading has been applied it is very strongly blocked in areas of dark shadows.

Handling pencil in this way requires confidence. When you are learning it is useful sometimes just to let go and have a shot at producing a strong image. You have nothing to lose – you can always have another try if your drawing goes wrong.

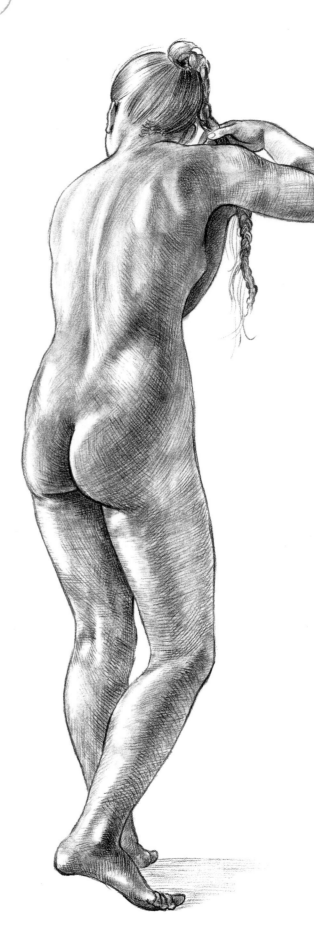

This meticulous pencil drawing, by the German artist Julius Schnorr von Carolsfeld (1794–1872), is one of the most perfect drawings in this style I've ever seen. The result is quite stupendous, even though this is just a copy and probably doesn't have the precision of the original. Every line is visible. The tonal shading which follows the contours of the limbs is exquisitely observed. This is not at all easy to do and getting the repeated marks to line up correctly requires great discipline. It is worth practising this kind of drawing because it will increase your skill at manipulating the pencil and test your ability to concentrate.

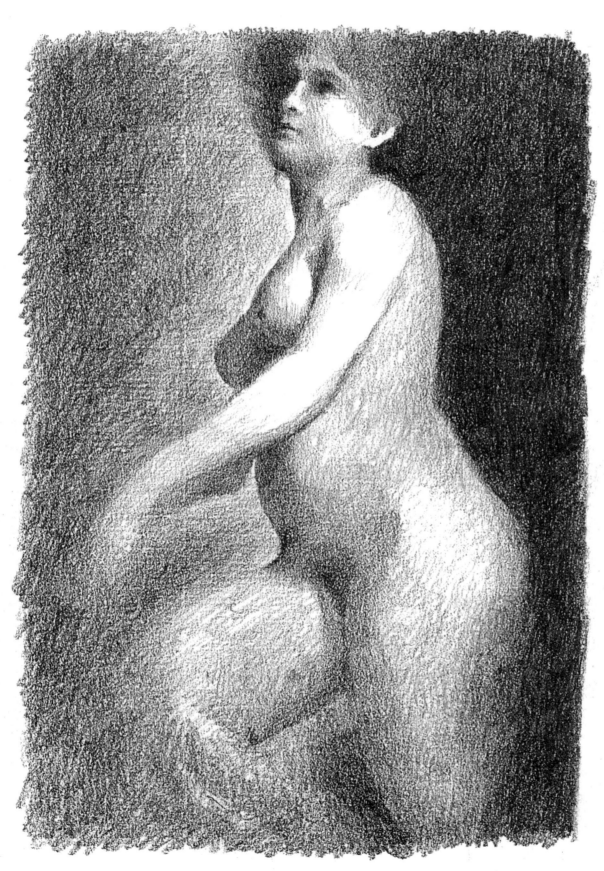

This drawing by the French Post-Impressionist artist Georges Seurat (1859–1891) is in a very different style to those we have seen so far, mainly because he was so interested in producing a mass or area of shape that he reduced many of this drawings to tone alone. In this picture there are no real lines but large areas of graduated tone in thick pencil and conté crayon on faintly grainy textured paper. Their beauty is that they convey both substance and atmosphere while leaving a lot to the imagination. The careful grading of tone is instructive.

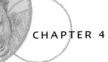

Pen and Ink

Pen and ink is special in that once the line is put down it is indelible. This really puts artists on their mettle mettle because, unless they can use a mass of fine lines to build a form, they have to get the lines 'right' the first time. Either way can work.

This example, after an original by Michelangelo, is very heavily worked over, with hefty cross-hatching capturing the muscularity of the figure. The texture is rich and gives a very good impression of a powerful, youthful figure. The limbs are unfinished, but even so the drawing has great impact.

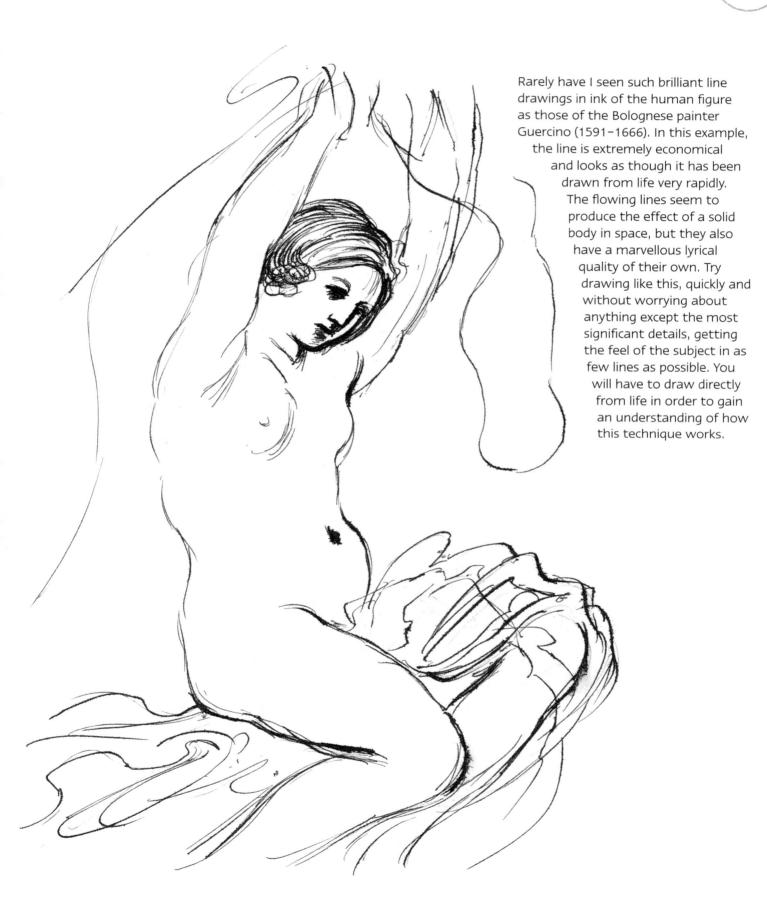

Rarely have I seen such brilliant line drawings in ink of the human figure as those of the Bolognese painter Guercino (1591–1666). In this example, the line is extremely economical and looks as though it has been drawn from life very rapidly. The flowing lines seem to produce the effect of a solid body in space, but they also have a marvellous lyrical quality of their own. Try drawing like this, quickly and without worrying about anything except the most significant details, getting the feel of the subject in as few lines as possible. You will have to draw directly from life in order to gain an understanding of how this technique works.

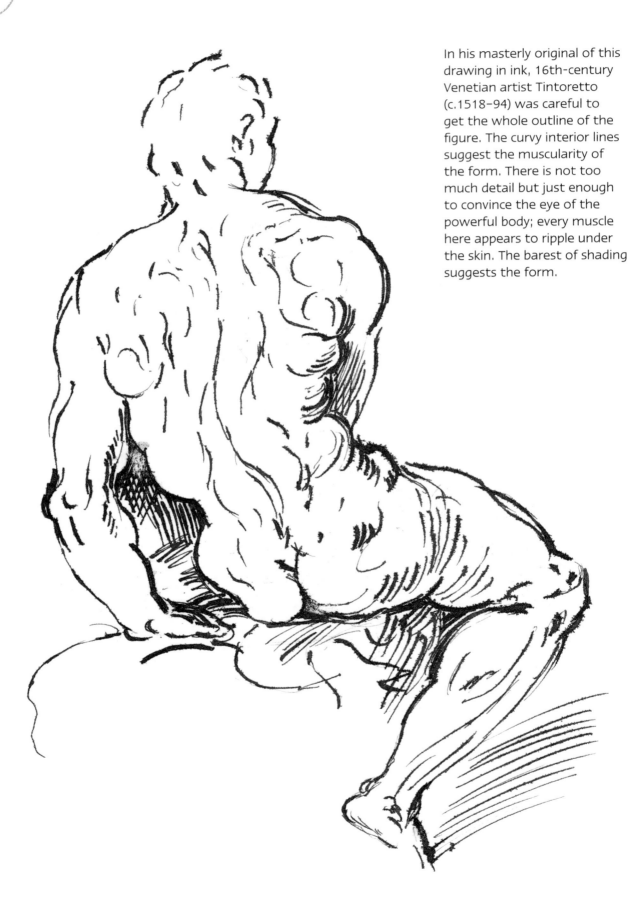

In his masterly original of this drawing in ink, 16th-century Venetian artist Tintoretto (c.1518–94) was careful to get the whole outline of the figure. The curvy interior lines suggest the muscularity of the form. There is not too much detail but just enough to convince the eye of the powerful body; every muscle here appears to ripple under the skin. The barest of shading suggests the form.

Line and Wash

Now we move on to look at the effects that can be obtained by using a mixture of pen and brush with ink. The lines are usually drawn first to get the main shape of the subject in, then a brush loaded with ink and water is used to float across certain areas to suggest shadow and fill in most of the background to give depth.

A good-quality solid paper is necessary for this type of drawing; try either a watercolour paper or a very heavy cartridge paper.

The masterful drawings of the Dutch artist Rembrandt van Rijn (1606–69) are the result of clear and accurate observation. This study of a standing nude is very dramatic in its use of light and shade, with highlighted areas of the figure left blank and deep washes of ink creating the shadows.

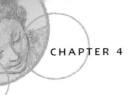

Chalk on Toned Paper

The use of toned paper can bring an extra dimension to a drawing and is very effective at producing a three-dimensional effect of light and shade. Remember that the paper itself is in effect an implement, providing tones between the extremes of light and dark.

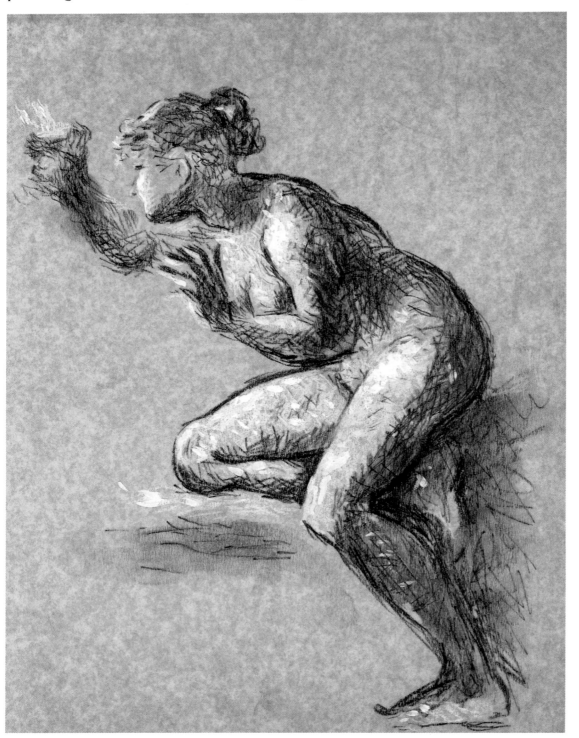

The French neo-classicist master Pierre Paul Prud'hon (1758–1823) was a brilliant worker in the medium of chalk on toned paper. In these copies of examples of his work, he shows us two very effective ways of using light and dark tones to suggest form.

In this drawing of Psyche (left), marks have been made with dark and light chalk, creating a texture of light which is rather impressionistic in flavour. The lines, which are mostly quite short, go in all directions. The impression created is of a figure in the dark. This is helped by the medium tone of the paper, which almost disappears under the pattern of the mark-making.

The chalk marks in this close-up are very disciplined. A whole range of tones is built from the carefully controlled marks, which show up the form as though lit from above. Here, too, the middle tone is mostly covered over with gradations of black and white.

Framing the Picture

A very useful tool to help you to achieve interesting and satisfying compositions is a framing device. It can be made cheaply by cutting it out of card to any size and format that you wish to work on. Looking through the frame, moving it slightly up and down, from left to right and even rotating it 90 degrees, will allow you to examine the relationship between the figure and the boundaries of the paper and visualize your composition before you actually begin to draw. It will also help you to see the perspective of a figure at an angle to you, as the foreshortening becomes more evident. Dividing the space into a grid will assist you in placing the figure accurately within the format when you draw it.

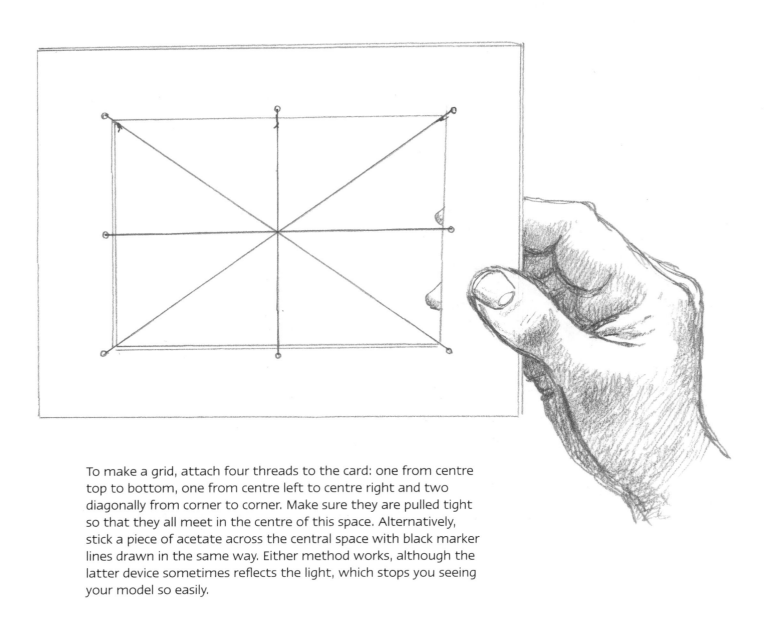

To make a grid, attach four threads to the card: one from centre top to bottom, one from centre left to centre right and two diagonally from corner to corner. Make sure they are pulled tight so that they all meet in the centre of this space. Alternatively, stick a piece of acetate across the central space with black marker lines drawn in the same way. Either method works, although the latter device sometimes reflects the light, which stops you seeing your model so easily.

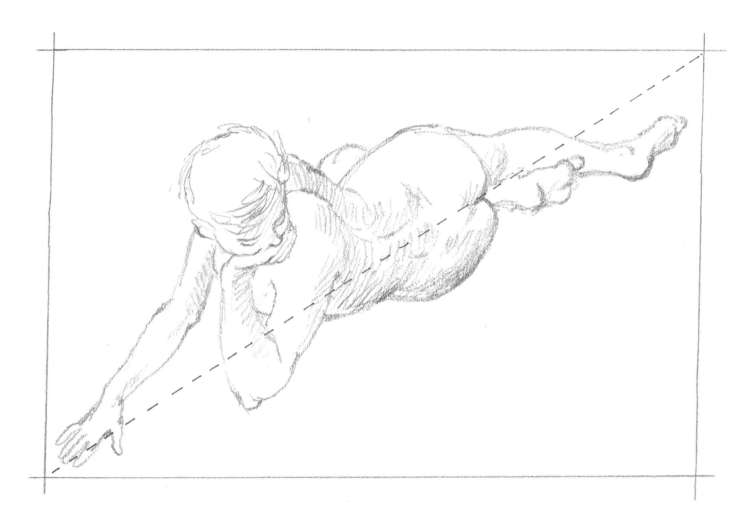

Here the edges of the frame are placed so that the figure appears to stretch from the upper right-hand corner to the lower left-hand corner. The centre of the picture is taken up by the torso and hips and the figure is just about balanced between the upper and lower parts of the diagonal line. This would give you a picture that covered the whole area of your surface but left interesting spaces at either side. You will find that it is quite often the spaces left by the figures that help to define the dynamics of your picture and create drama and interest.

Using Geometry

Looking for simple geometric shapes such as triangles and squares will help you to see the overall form of a figure or group of figures and achieve a cohesive composition within your format. The use of geometric shapes can become a straitjacket if it is taken too seriously, but it is a good method to use as a guide because it puts a strong underlying element into the picture.

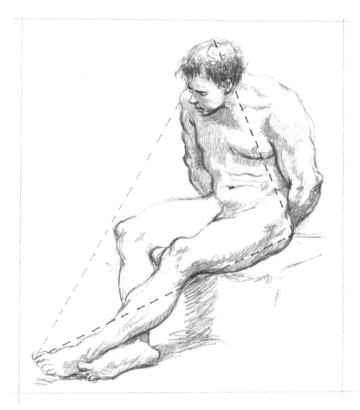

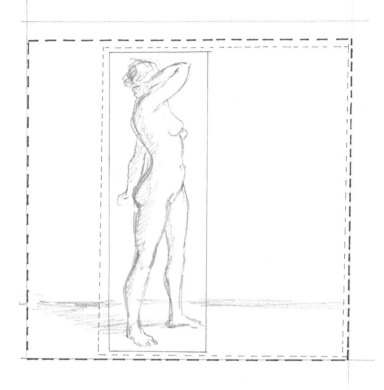

This seated man with his hands behind his back, based on a drawing in the Louvre by Charles-Joseph Natoire (1700–77), fits into an elongated triangle with the corners at the top of his head, the back of his hip and the end of his toes. The bulk of his body is between the sides of the triangle, and because the emphasis is on the stretch of his legs to the bottom left-hand corner of the picture there is a strong dynamic that suggests he is under some duress – perhaps a prisoner. This simple device produces an emotional effect in the drawing.

This standing figure of a woman turning away from the viewer shows a gentle dynamic pose with a strong, straight, upright shape. You might choose to fit the edge of the picture closely around her, as shown by the unbroken line. This is the simplest possible composition, making the figure fit in as in a box. Alternatively, you could use a space as shown by the rectangle with the lighter broken line, which encloses a large amount of space over to her right. Here she is on one side of the composition and the space suggests airiness and the light that is falling on her from the right.

A third choice of composition, shown with the heavier broken line, places her in a space which gives her room on both sides, making a dynamic out of the larger space to the right and the smaller space to the left. It also seems to set her back into the square more effectively, lending distance to the view that didn't occur with the first two compositions.

More Complex Geometry

Make a practice of studying complex compositions to see where geometric shapes link to hold the figures together. Doing so will help you to think about incorporating such shapes into your own pictures as a matter of course.

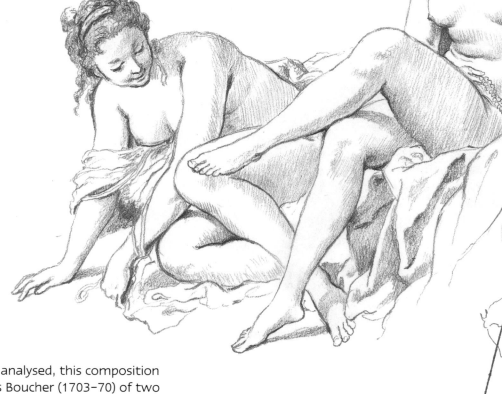

When it is analysed, this composition by François Boucher (1703–70) of two goddesses or nymphs at their toilet becomes a complex series of interlinking triangular shapes. The main thrust through the picture goes from the lowest hand on the left up through the knee and leg of the higher figure and on to her upper shoulder. From her head to elbow is an obvious side of a triangle from which two longer sides converge on her lower foot. The line from the higher figure's upper leg along the back of the lower figure produces another possible set of triangles that go through the feet and hand of the lower figure. These interlinking triangles produce a neat, tightly formed composition that still looks totally natural and ideal.

Interlocking Figures

When it comes to compositions involving more than one figure, the biggest problem, assuming you have had enough experience of drawing live figures, is the way that parts of one figure disappear behind parts of another. Sometimes it is easy to get the composition wrong and end up with an awkward-looking arrangement.

This drawing of two Victorian wrestlers is based on a painting by William Etty (1787–1849). One figure is being forced down, but the standing figure looks as though he might be levered across from the lower figure's knee. The main point of this picture is the forcefulness of the action and how the two figures are struggling against each other. Perhaps Leonardo (1452–1519) or Michelangelo would give us more expression of the struggle; but nevertheless, this composition does evoke the effort that these two strongmen are making.

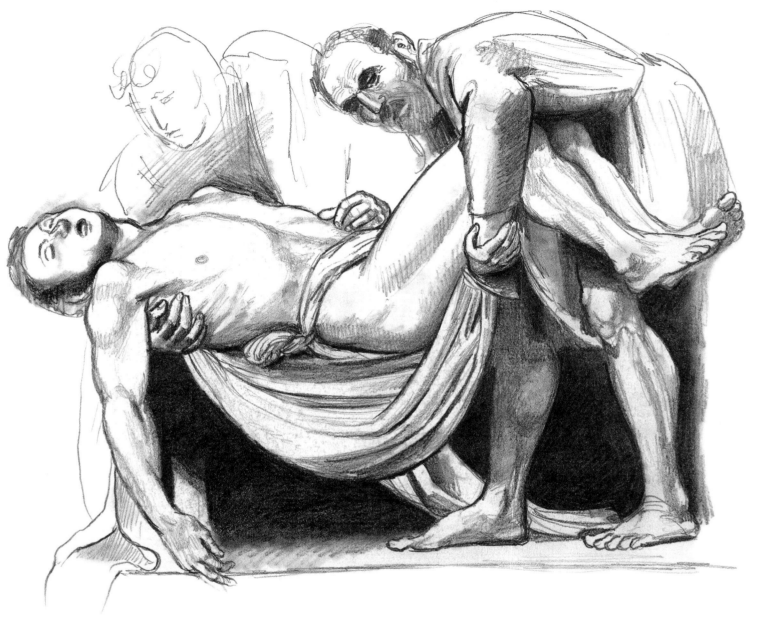

In this copy of a painting by Baroque artist Caravaggio (1571–1610), the body of Christ is being lifted into its tomb. This event is made interesting and dramatic by the arrangement of the figures and their relationship. The movement of the figures carrying the dead body contrasts starkly with the inert corpse, while the limpness of the legs of the dead man contrasts with the gnarled knotty legs of the carrier on the right. The shape made by that man's encircling arms and the figure with his arm under the shoulders and back of Christ are quite complex. Even the strands of grave cloth and the cloak of the younger carrier help to define the activity.

I have omitted from my copy the group of three mourning women which is in the original, because they are not actively engaged in carrying the body.

Multiple Figures

Compositions involving three or more figures require a high degree of planning and it is likely you would need to create separate studies of each pose in advance. There is much to be learned from studying the works of master artists, many of whom used nudes in their portrayal of classical and mythological themes.

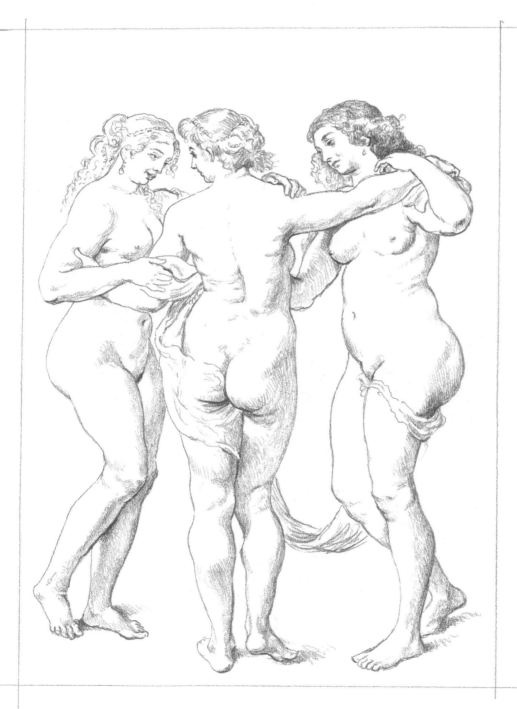

For an example of a three-figure composition I have drawn *The Three Graces* by Peter Paul Rubens (1577–1640), the great master painter of Flanders. He chose as his models three well-built Flemish women, posed in the traditional dance of the graces, hands intertwined. Their stances create a definite depth of space, with a rhythm across the picture helped by the flimsy piece of drapery used as a connecting device. The flow of the arms as they embrace each other also acts as a lateral movement across the picture, so although these are three upright figures, the movement across the composition is very evident. The spaces between the women seem well articulated, partly due to their sturdy limbs.

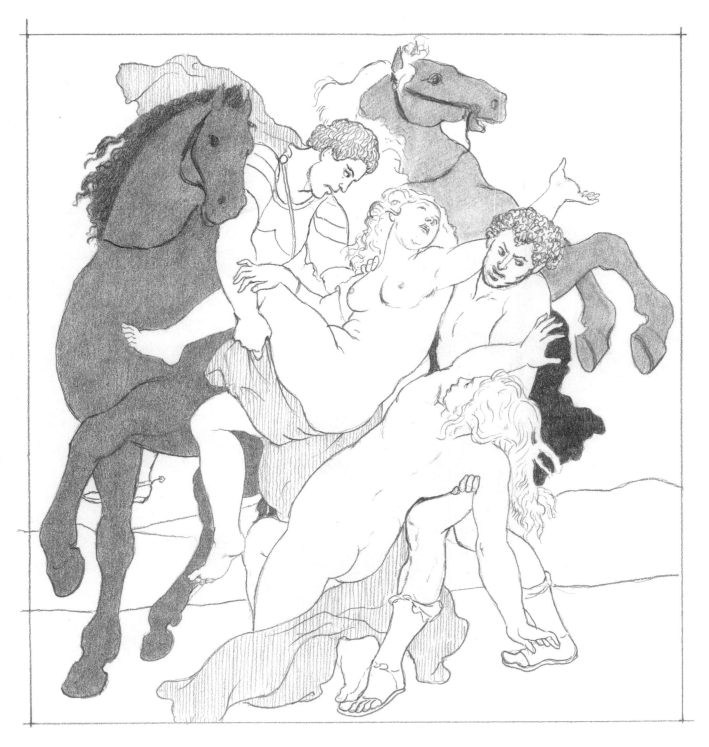

In another picture by Rubens, *The Rape of the Daughter of Leucippus*, the composition is of four figures; the two horses act only as devices to lift the figures off the ground. The extremely vigorous swirl of movement between the two women being dragged off by the men, with the figures all leaning at different heights and angles, creates a tumultuous composition. The struggling bodies and the prancing horses were probably based on Leonardo's turbulent horsemen in his drawings for the *Battle of Anghiari* fresco.

Index